Elements of Colour Photography

The Making of Eighty Images

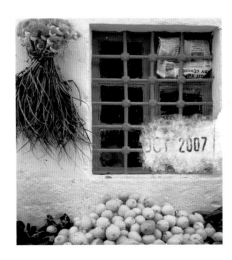
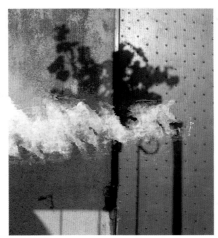

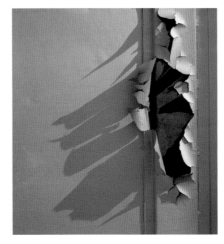
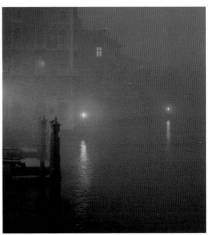

A Photo Anthology by George E. Todd

Argentum

First published 2003 by Argentum,
an imprint of Aurum Press Limited,
25 Bedford Avenue, London. WC1B 3AT.

A catalogue record for this book is available from the British Library.

ISBN 1 902538 30 7

Design: George E. Todd
Layout: Louise Ang

Printed in Hong Kong

10 9 8 7 6 5 4 3 2 1
2007 2006 2005 2004 2003

Thanks

To thank everyone who helped me as a newcomer to 'serious' photography, or offered guidance gratefully accepted in my most formative years, would result in a list of names like Hollywood film credits – and mean little outside this circle of friends. In particular, I must thank Jörgen Hanson formerly of Hasselblad AB Sweden and now retired. Gratitude is also long overdue to Malcolm Tarkington in Huntsville, Alabama; his kindness and generous help came at a critical time in my development as a darkroom worker.

Belated thanks are also due to Dr Walter Müller and Horst Haupt in the then Ilford Cibachrome production plant at Marly near Fribourg, Switzerland. Their colleagues Matthias Schneege in Germany and Mike Gristwood in England too, I thank.

Thanks also to Rupert Foierl who kept my computer and sanity in good health.

But above all, without my wife Patricia's enthusiasm for travel to distant places this book might never have happened.

Contents

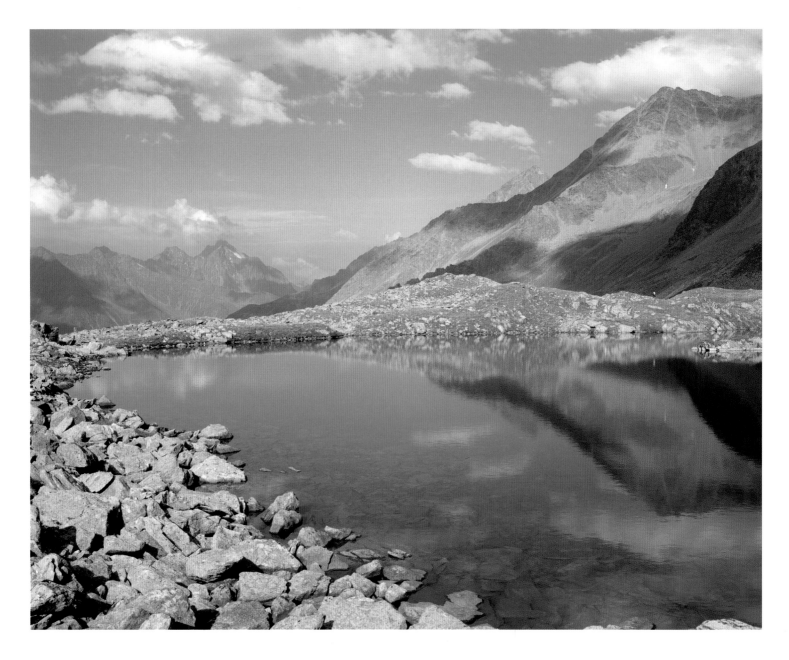

Frontispiece: Mutterbergersee

Austrian Alps 1990; Fuji RDP. Ikeda 4 x 5 Wood View

Introduction

After a long period in the Elysian Fields of black and white fine art photography, it was a refreshing change to concentrate again on colour. The trigger for this was a small exhibition of twenty Ilfochrome prints, half of which were sold to a collector – prompting me to think that colour is the preferred medium. It also provided the boost to prepare this anthology.

Many years ago, someone said to me: 'you photograph colour as if it were black and white', a comment that puzzled me for some time until I realized he was talking about the use of strongly contrasting forms and shadows. Normally such high contrast is best avoided in colour. Nonetheless, I enjoy exploiting this to illustrate line and form, shapes and structures, to use colour itself as a compositional tool.

The pictures that follow were seen through that indefinable 'inner lens', an eye that sees intuitively. Almost anything that appears in my viewfinder – dancing shadows, a bundle of old newspapers, reflections on a freshly painted boat, or a strip of plastic fluttering in the breeze – is enough to fire the imagination. It is a mode of photography thriving on spontaneity. I might like to capture the motif as seen, or visualize it as a quite different abstract image derived later by darkroom manipulation.

As a would-be artist, now sixty-five years out of art school, I keep a foot in two camps: Realism and Impressionism. While wearing my realistic hat, I like photographing a familiar object in some unusual aspect – reduced as it were to its bare bones, as in *Chair lift* (p.11).

My other metaphorical foot rests firmly with the nineteenth century Impressionists, whose exuberant brushwork and juxtaposition of colours has greatly influenced me over the years. Confronted by their paintings in museums and art galleries, I see how much they shaped my view of this colourful world.

There have been fewer influences from the world of straight photography, even though some of my work could be viewed as following in the footsteps of Ernst Haas, Eliot Porter, Aaron Siskind or Pete Turner. I refute all charges of directly copying any of the established masters; if one is adventurous and adept at breaking a few rules (who set these anyway?) then similar images will come tumbling out of nowhere. The art is to catch them in a way that is clearly your own…

People often ask me: 'What makes a good photograph?' Essentially, it is a combination of several factors: primarily imagination and sensitivity, having a feel for the subject, living or inanimate – and occasionally a bit of luck! To some extent it depends on the motif too, but most of all on *the way* it is seen and the impact it makes.

It has nothing to do with cameras, lenses or films, but rather on what happens in the photographer's head at the moment of inspiration. When all these factors unite, the result is more than a two-dimensional eye-catching picture; it might even be called a work of art. And if it compels people to stop and look, that's okay; if it moves them to tears or smiles it has reached out and left a powerful bookmark in their memory.

Whether in black and white or colour, the actual medium is almost irrelevant to the success of an image – and yet the high

priests of 'Fine Art Photography' have regarded colour like an unloved stepchild. In my opinion, equal recognition of colour and black and white as art is long overdue. To elaborate this point, an outline of colour photography's beginnings would not be out of place here. Indeed, I feel it is necessary, but it will probably be the shortest history of colour photography yet written.

Following other less successful contenders, e.g. Thomas Wedgwood (1802) and Nicéphore Niépce (1827), William Henry Fox-Talbot and Louis Daguerre showed they could make a stable image by photomechanical means, announcing their discoveries in 1839 quasi-simultaneously to the wide world. Fox-Talbot had devised a negative-positive repeatable method while Daguerre used highly polished silvered-copper plates for a reflected unique image. Photography was thus already well-established sixty years before the Lumière brothers, Auguste and Louis, revealed their experiments to make colour films.

The Lumières' research resulted in 'Autochrome Plates', the first commercially viable transparency process introduced in the early years of the twentieth century. Their invention, which used microscopic grains of dyed potato starch, was based on the trichromate additive colour system, as demonstrated by James Clerk Maxwell convincingly at the Royal Society, London in 1861.

Digressing for a moment, it is fascinating to note that in 1907 at Tutzing, an attractive lakeside resort on the Starnbergersee in Bavaria, four legendary masters of photography – Frank Eugene, Heinrich Kuhn, Edward Steichen and Alfred Stieglitz – experimented with Autochrome colour plates to consider their future in photography. The portraits they made of each other are vintage masterpieces and witnesses to this extraordinary event.

Tutzing is only fifteen kilometres from my home, and as an honorary member of a local photo club I once proposed a re-run of this historical meeting, with three others and myself (all bearded of course and dressed in period clothes) but there were no takers. Maybe I should try again, with the impact of digital photography as the theme...

Returning to my short history – despite efforts by others, e.g. Dufaycolor, Thames and Finlay Plates to manufacture similar products, Lumière Autochromes remained popular until shortly before World War II, when a new generation of colour films appeared on both sides of the Atlantic. The essential difference lay in their break with the additive colour method, going over to a subtractive concept. But even this had long been proposed and patented in 1868 (!), in France by Louis Ducos du Hauron. Agfa led the way with the first 'colour-forming' emulsions, patented some thirty years earlier in London by a far-sighted German photo-chemist, Dr. Rudolf Fischer, while in America two amateur musicians, Leopold Godowski Jnr. and Leopold Mannes, formulated the unique Kodachrome using colour-forming chemistry. The Agfa approach was adopted later by Kodak with Ektachrome using a simplified six-bath developing process.

The exciting post-war improvements in photo-technology gave photography a new means of expression, especially in colourful advertising, helped by modern offset printing methods. Professionals prospered as magazine and travel photography boomed, while amateurs indulged their passion for 'true colour' slides – until the single most feared sentence in the English language became: 'Would you like to see my holiday slides?'

Let me show you a few of mine!

CHAPTER ONE
Quasi-Graphic

Having already fallen into the categorization trap by allocating the first two chapters in my work plan to *graphic* and *pictorial* subjects, it was inevitable that I would run into difficulties with definitions. In opening Chapter 2, I suggest that the term 'pictorial' covers practically any area of photography. The problem is that there is little difference, if any, in meaning between graphic and pictorial; indeed they appear in the same bracket in *Roget's Thesaurus* under 'graphic', subheading: 'representation'.

Several other logical divisions spring to mind, such as portrait and nude studies, documentary, architectural and historical. Some might even say that rusting locomotives as portrayed in Chapter 4 under the rubric *Transitions* could well be regarded 'photo-historical', recording the demise of a nation's railways at a particular point in time – and I wouldn't argue with that.

Personally, instead of such multiple pigeonholing, I would prefer two simple all-embracing titles: *Photography*, which in my opinion would cover most, if not all 'normal' pictures in colour or monochrome. The other heading would be *Applied Photography*. This grouping would include scientific, medical, forensic and industrial applications, and most other specialist branches of professional photography. Perhaps another sub-section would be needed in this contentious and rather simplistic list of categories, to cover the stuff of our daily media: reportage – not forgetting sport of course.

For me, this image below symbolizes the simple approach. Seen on the island of Lemnos, it was a Greek fisherman's way of stopping the rain and spray beating into his boat's wheelhouse – a typical quick fix that maybe stayed that way for ages, the quintessential Mediterranean way of life. But at least it worked and was probably easier than trying to find another piece of glass.

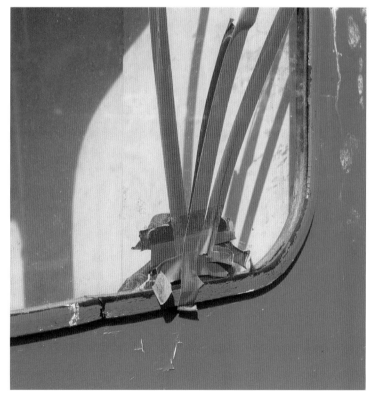

...but only when it rains

OPENINGS

Riviera revelations

The picturesque fishing harbour of Camogli near Genoa, Italy is where I began to create artistically satisfying images – to see *photographically*. It happened quite suddenly during the Christmas holidays of 1978, and was perhaps a combination of many factors: the quiet atmosphere, the Riviera's food and wines, but above all a fine new camera: a Hasselblad 2000 FC.

After years of using smaller formats, I was beginning to feel cramped by the 2 to 3 ratio of the 35 mm format; there always seemed to be something beyond the image frame. Then I made that quantum jump, taking the chance while working in Sweden to buy a Hasselblad – its big $2^{1}/_{4}$ inch square image was so inspiring that even simple shadows had poetic appeal, opening new views of the world.

While I was snooping around for other motifs, Patricia was engrossed in a careful scrutiny of restaurant menus – her favourite activity around noon, and as it was already well beyond midday the search was becoming critical. But instead of a menu, my attention was focused on a piece of paper torn out of some unidentifiable magazine lying on the knee-high sea wall. The paper contained some scraps of sardine-sized fish, dried remains of bait left by a fisherman who had maybe gone in search of something more appetising.

Being an almost flat motif, there was no need for a great depth of field – it was enough to make a simple hand-held shot with the standard 80 mm Zeiss Planar lens, though I have no idea what the settings were.

Then came the cry: '*Mangiare*! This looks like a good one',

meaning the kind of fare on offer at a nearby trattoria. I had to go; but at least the picture was in the can.

Back home, the developed result came as a surprise. In my haste to get this image, I had concentrated solely on the fish bait and its shadows – the tinned-ham advertisement featured on the crumpled magazine page had completely escaped my attention; after all, it was just a piece of scrap paper. Quite unintentionally, the wine and bread eminently matched the notion behind this image. For a simple snapshot it is astonishingly sharp, with the advert's colours harmonising with the dead fish; even the glass of red wine seems to glow in a well-lit Ilfochrome print.

With *Camogli I* on the cover, *Mangiare* was published in 1981 by Hasselblad house magazine along with four others from this first 2000 FC film. I wondered at the time why the editor was so attracted to the shadow image; it breaks conventional rules of composition, with a vertical line dividing the image into two parts – but who's to say what's right or wrong in art.

I returned nearly a quarter of a century later to the Riviera, hoping to see some new images along the same lines as these opening shots, but found it almost impossible by car to get anywhere near the seaside town centres. Fortunately, buses and railways do run an effective service along this famous coastline, winding through cliffside tunnels and the delightful inlets, a land that inspired many writers including Lord Byron – and Percy Bysshe Shelley who drowned in its blue waters.

Camogli I
Camogli, Italy 1978; Kodak KR 64. Hasselblad 2000 FC

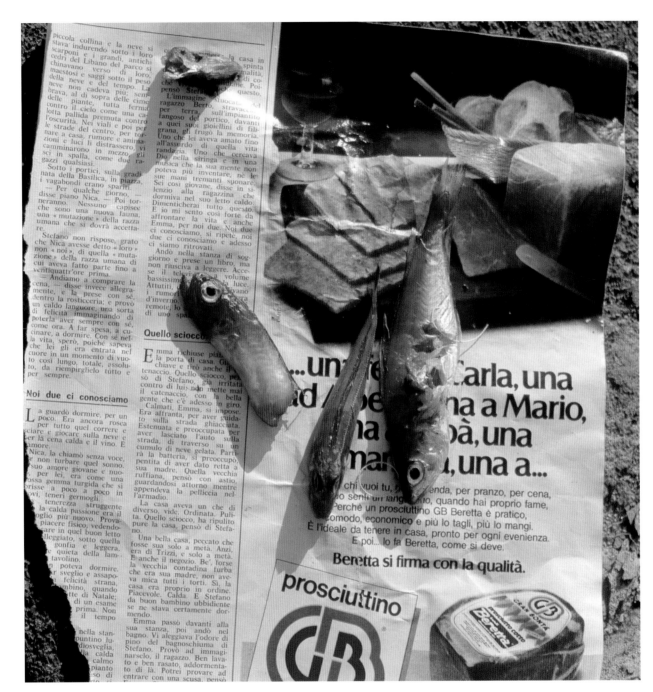

Mangiare

Camogli, Italy 1978; Kodak KR 64. Hasselblad 2000 FC

The colours of Greece

Sifnos, Greece 1987; Fuji RDP. Plaubel Makina 67

Greek island days

There are well over one hundred Greek islands – some are really large like Crete or Kithera, others are small and normally uninhabited. Having travelled around thirty-two of the more accessible ones, it is hard to choose a favourite; in fairness they all have something special worth remembering.

For a start there are Amorgos and Astypalea, or Paros, Kea and Kithnos, criss-crossed by rocky tracks winding between dry-stone walls that give one a powerful sense of continuity with the classical past. Then there's Patmos, Sifnos and Syros for their quiet Mediterranean charm, and defiant Symi for its neo-classical architecture (mostly in ruins) or Lesbos, Chios and Lemnos – the list goes on and on…

Springtime in the islands is a wonderful experience, a time when the air has that special clarity under smog-free skies of Grecian blue. It is the season that inspires photographers to blow a winter's dust off their equipment and switch their imaginations to high sensitivity. There's an unlimited range of pictures in the taverns, the old mountain villages, or in the kaleidoscopic boat-filled harbours where often the best images are found. And for the botanical enthusiasts the fields are full of wild flowers such as we rarely see today in our over-sanitized countryside. I recall being covered in yellow pollen (a nightmare for some) while photographing a field looking more like something from Claude Monet's brush. But besides nature's colours – fields of lupine blue, or swaths of yellow speckled red with poppies – there is an abundance of man-made colour on the Greek islands. Colours just seem to leap at you from all angles.

Take Santorini for instance – a photographer's paradise with its panorama of blue basilica domes, white bell towers and black cats lazing in the welcome shadows of cool walls. Little wonder then, that I revelled in a kind of 'blue period' in my

Greek island days. Blue (and white) seems to emanate from every angle, nook and cranny. The brilliant light, the sea, the sky and even the shadows combine to saturate the place in blue. The problem was how to avoid the familiar cliché postcard or calendar image, how to illustrate this atmosphere with something different. I found it in the form of *Cubist blues*, seen on a quiet cliff-top walk to visit Agios Stephanos, the oldest church on the island at Skaros.

Monet's brush…
Sifnos, Greece 1987; Fuji RDP. Plaubel Makina 67

Cubist blues

Santorini, Greece 1985; Fuji RDP. Hasselblad 500 CM

One of the southernmost Cycladic islands, Santorini is a favourite place to watch the setting sun from its tall, layer-cake cliffs – colourful strata, rich in volcanic minerals and varying from pale sandy tones and ochre, to basaltic black. The island is a remnant of a natural disaster that occurred about 1450 BC when a volcano, which had been regularly active in prehistoric times, blew up with a violence that destroyed the whole island, like Krakatoa in modern times.

The gigantic tidal wave, or *tsunami*, that swept through the eastern Mediterranean is known to have wreaked tremendous havoc around its shores. All that was left of Santorini was the horseshoe shaped island we know today. Its destruction led to the Atlantis myth, an antique world that sank beneath the waves – in all probability, the great Minoan civilization of ancient Crete. Now, out in the bay one can visit the sulphurous fumaroles in a new crater, or swim in the lagoon-like sea warmed by thermal waters still rising from the subterranean source of this restless energy.

Many great names in the world of photography roamed the Greek islands: Eliot Porter produced one of his several volumes of masterworks, *The Greek World*, based on travels around the blue Aegean. Every time I think of Santorini an inseparable icon comes to mind: German photographer Herbert List's *Goldfish in a Bowl*. Henri Cartier-Bresson captured one of his famous decisive moments in the back streets of Sifnos, the *Potter's Isle* – an image that may have subconsciously triggered this street scene in Paros. In truth, I made it to show how even a power supply line could be an attractive picture.

Sitting in the Outer Cyclades (an island chain that includes Kea, Kithnos, Serifos and Milos, of Venus fame) Sifnos is famous for its cuisine and olive oil, and a pottery industry that goes back to the 8th century BC. It reached its commercial peak a *thousand* years later, but by the end of the 20th century the

Paros, after HC-B

number of active artisans had shrunk to a handful of ageing masters. Sifnos is popular now with hobby-potters sharing a slice of the restful island life with photography and painting workshops-cum-holidays.

A cheerful group of American artists were busy with various watercolour renderings of the village square, but somehow they missed the appropriate red, white and blue motif of my cover picture.

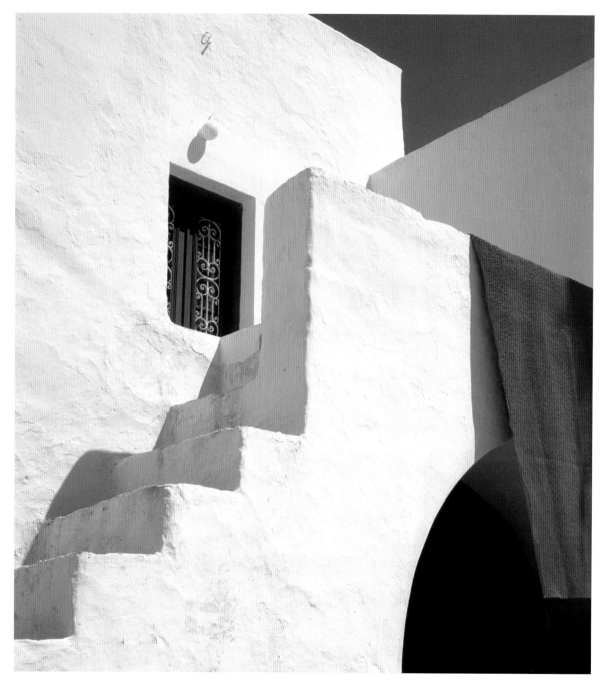

Colour vision, Sifnos 1987

Sifnos, Greece 1987; Fuji RDP. Plaubel Makina 67

The old hot tips are almost certainly on the main tourist circuit now as aircraft and ferryboat connections become more frequent. Back in the Eighties, travel between the islands was a real challenge. I was stuck on Astypalea for ten days when the twice a week boat was delayed – war between Turkey and Greece again threatened to disrupt the entire region. All boats had been commandeered to take women and children to the Greek mainland, leaving the bars full of men angrily debating the situation. It looked more serious than usual.

Like many popular Greek islands, Paros is probably more overrun now than it was in the mid-Eighties. Called the 'White Island' of the Cyclades, it is best visited no later than the Orthodox Easter weekend and certainly before the package tours and cruise ships arrive. One of several Dodecanese islands of volcanic origin, Patmos enjoys a different sector of tourism, namely visitors interested in the island's historic biblical connection. Around the close of the first century, John of Ephesus (St John the Theologian) was exiled to Patmos where he wrote the *Book of the Apocalypse* or *Revelations*. During World War II, St John's monastery was the scene of extraordinary neutrality when British, German and Italian soldiers hid in different parts of the same ancient building, a bizarre story related in Lawrence Durrell's *Reflections on a Marine Venus*.

Those distant island days were some of my happiest creative times, a period when images just seemed to fall continually out of the blue Grecian sky. Like the time I was sitting in a cafe-garden quietly enjoying ouzo and coffee – just minding *everybody's* business – when suddenly a white plastic chair disturbed the idyll: an inexplicable urge came over me to photograph it.

Pictured in my mind's eye, the chair made a super image set against the deep blue sky, but as Patricia lifted it high above her head I also saw that she would tolerate my nonsense for only a few seconds, enough for two quick snapshots. The result, *Chair lift,* was derived from the original transparency whilst I was preparing one of my annual summer exhibitions – a typical post exposure revision underlining my penchant for graphic design. It resulted in a picture that goes well with modern furnishings – often the reason why folks buy these images!

In a small sunlit square on Tinos, in the northern end of the Cyclades, an image on an unfinished building literally popped out of a wall. A bunch of coloured wires sticking out of the freshly plastered wall, ready perhaps for an electrician to install some external device, inexplicably reminded me of Joan Miró's work – an artistic connection that exhibition visitors see too, without prompting. Tinos incidentally, is well known for its house-sized dovecots, homes for flocks of birds that fly away as soon as a camera is pointed their way.

Symi

Sequestered in the blue Aegean waters, just a few sea miles from the Turkish mainland, little Symi was one of the many attractive places I visited in my island-hopping days. During the Eighties, Symi was a quiet spot except when the daily tour boats arrived with a few hundred holiday makers; but by four o'clock most of them were on their way again, back to Rhodes. There were no cars in those days, not even a road – a situation that caused much hilarity as a successful former Symiote living in America, decided to present a city bus to the island. Things have surely changed somewhat since then.

Chair lift

Lesbos, Greece 1989; Fuji RDP. Plaubel Makina 67

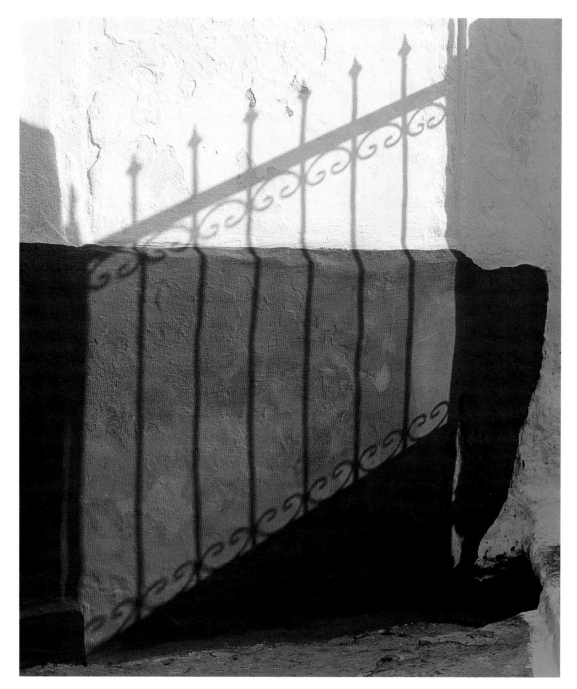

Red wall

Patmos, Greece 1986; Fuji RDP. Hasselblad 500 CM

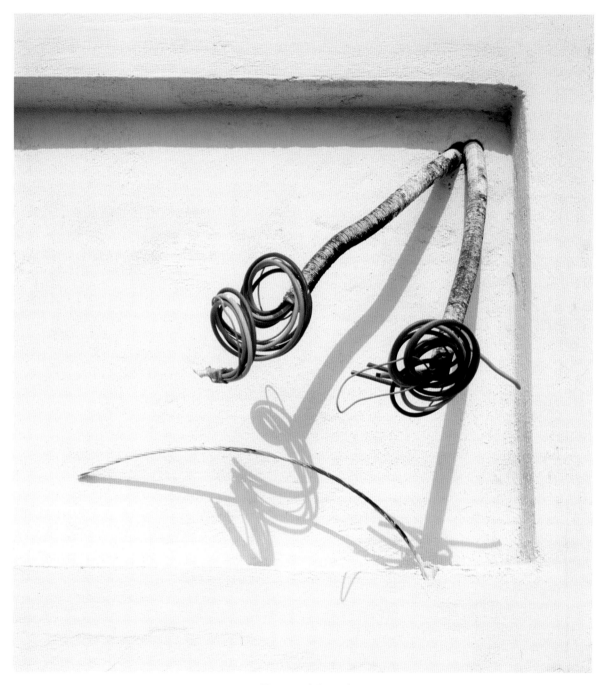

Homage à J. Miró
Tinos, Greece 1986; Fuji RDP. Plaubel Makina 67

13

From the Hellenic period to present times, Symi's shipbuilding inhabitants have been renowned for their speedy boats, much prized by rulers of the eastern Mediterranean. This led Sulaiman the Magnificent to grant a degree of independence to Symi. He also received an annual tribute of the sponges for which the island was famous.

Symi flourished to such an extent by the nineteenth century, that many of the richer merchants built ostentatious mansions that still dominate the old town. Several have been reduced to ruins, the result of none-too-accurate bombing by both sides during World War II. But while I found these sad remains a rich source of abstract art, it was Symi's busy shipyard that drew me irresistibly to a veritable cornucopia of images. Little boats were being cleaned up, re-caulked and painted, ready for the coming season – the smell of work was everywhere.

The town's photographer was busy too when the tour boats came in each day. With an array of three battered Nikons hanging round his neck, he would snap each person stepping off the ship's gangway, then dash off to develop the films. By the time the tourists were ready to depart, three hours later, he would have a hundred or so postcard-sized prints pegged out on a stand. He always seemed to sell a few at a hundred drachmas each, but the rest would be scrapped along with the films.

Looking in to see him one day I saw the most astonishing heap of film wriggling like a bush in the draught blowing through the cliff side cavern, down by the harbour, that served as his laboratory. His rusty enlarger would have made an unusual candidate for my still-growing series of Fe_2O_3 images.

The numerous neo-classical buildings encircling Symi's harbour ought to have inspired me to explore the many forms of architecture – the tympanums, columns and architraves of what had clearly been imposing houses around the turn of the last century. Strange to relate, my Symi collection has only one purpose-made architectural image: a concrete monstrosity newly built on a rise, overlooking the panorama of elegant mansions, albeit shadows of their former glory.

Symi steps

Corners I, Symi
Symi, Greece 1985; Fuji RDP. Plaubel Makina 67

A tale of two zebras

The Sonoran desert straddles the south-western border of the US, extending from Sonora in Mexico into central Arizona. A region of great natural beauty, it is famous for the massive Saguaro cacti that grow several metres high. But not everyone wants to go roaming the wild and dangerous desert, and will feel safer visiting the famous Desert Museum, a few miles south of Tucson, Arizona.

Arthur Pack, the wealthy publisher of the prestigious magazine *Nature*, founded the museum after donating his Ghost Ranch to the United Presbyterian Church in 1955. Pack's former estate, where artist Georgia O'Keeffe also lived and worked in her 'Faraway', is now an adult study and conference centre.

A popular attraction at all times of the year, the Desert Museum houses a superb collection of plant and wildlife species in a twelve-acre natural desert setting. I found the indoor exhibits were a convenient way of escaping the awesome heat before venturing out again into the desert sun. It was in one of those cooling-off intervals, that this extraordinary shadow thankfully delayed my return to the oven outside.

Years later, on the Greek island of Santorini, I chanced on *Zebra Two* while sipping a morning coffee in the soft spring sunshine and relaxing on the roof terrace of a *Kafeneon* overlooking a mother-of-pearl Aegean. Shining through a shady pergola, the sunlight was casting a voluptuous striped shadow over a huge Ali Baba-sized pot, forming an image strikingly similar to *Zebra One*.

Zebra One

The odd thing about both of these images, is that the foreground appears to be rippled, a floor surface that was actually not there; it was just a trick of the light – an illusion, and nothing to do with the photography. In *Zebra One* the sandy foreground (seen above) was quite flat, while the terrace where *Zebra Two* stood was level, smooth concrete.

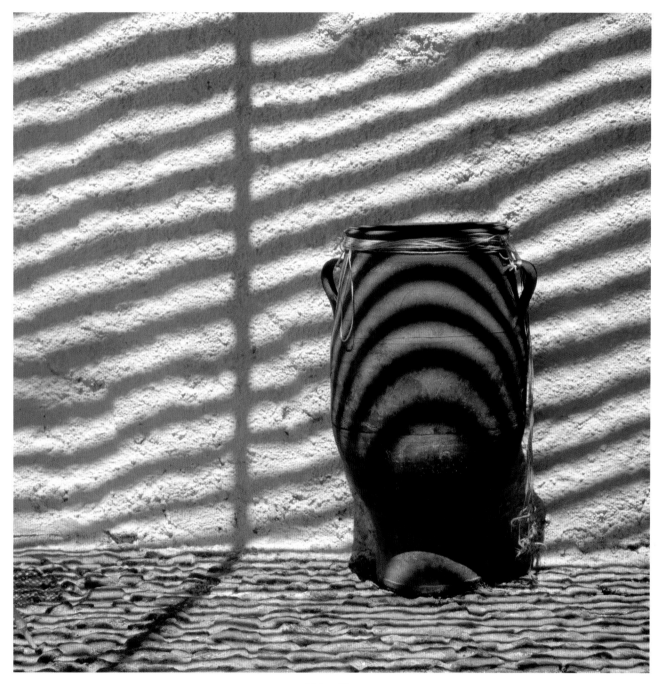

Zebra Two

Santorini, Greece 1985; Fuji RDP. Hasselblad 500 CM

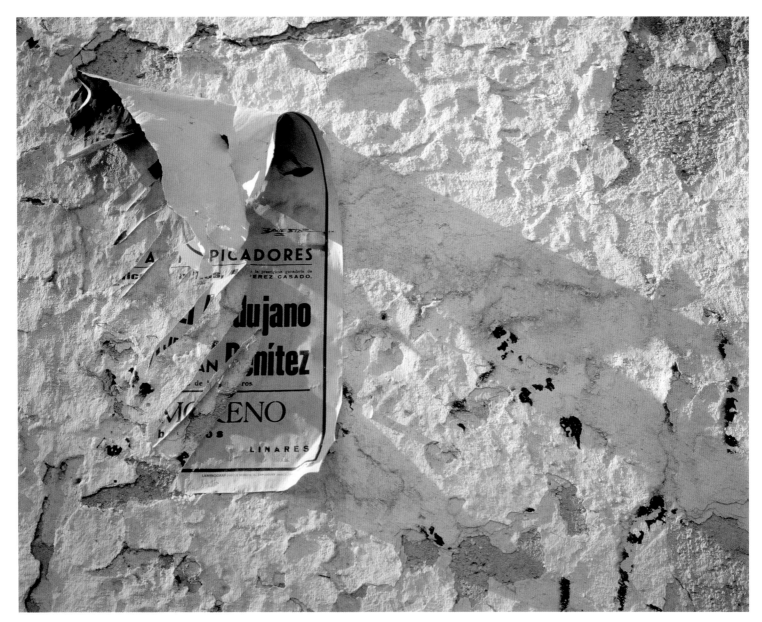

Vamos! Picadores (Remains XI)

Linares, Spain 1992; Fuji RDP. Plaubel Makina 67

REMAINS

Tattered and torn

Posters of bygone events always attract me, especially when they are reduced to tatters by the ravages of time. Like Picadores on the previous page, the title occasionally visible as it flapped up and down in the breeze. A 1/500th of a second stopped its motion so well that one can read the printer's name.

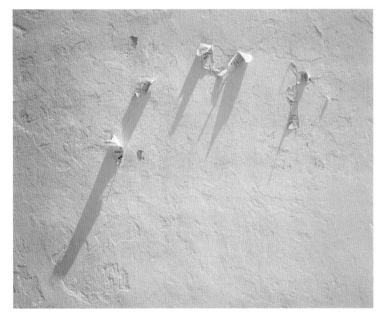

An extreme example sidetracked me on the Greek island Kalymnos, where bits of a political poster and the afternoon sun combined to cast long graphic shadows on the whitewashed plaster. As I photographed the apparently blank wall a local inhabitant gave me a wide berth as he walked anxiously past.

Walking back to my office after lunch one Friday afternoon, I spotted a patch of rust exposed on our flight operations hangar door. A huge paint blister had burst open, throwing a graphic shadow – three of my favourite motifs in one image.

My immediate reaction was to rush home for the cameras before someone started a repainting job. It was a silly idea really – I mean, who ever heard of a sun shadow staying stock-still; the world would explode if it stopped rotating! Even so, the weekend was spent fretting over this image hoping that nobody would begin to wire-brush away the rust and flaking paint – again pointless, as it was ages before the airfield maintenance crew was even aware of it.

A similar shadow had caught my attention some years earlier. Driving along a service road into downtown Huntsville, Alabama a derelict door, with extraordinary peeling veneer panelling flaying in the wind, literally cried 'Stop!'. Leaving a couple of skid-marks (yes, I *did* check the rear-view mirror first!) and a surprised passenger in the car, I leapt out to catch the strands of wood on film with a couple of free-hand shots.

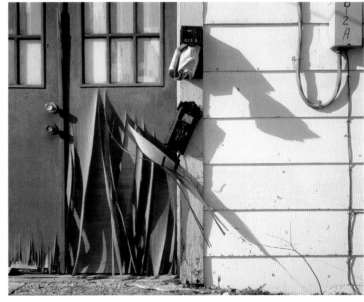

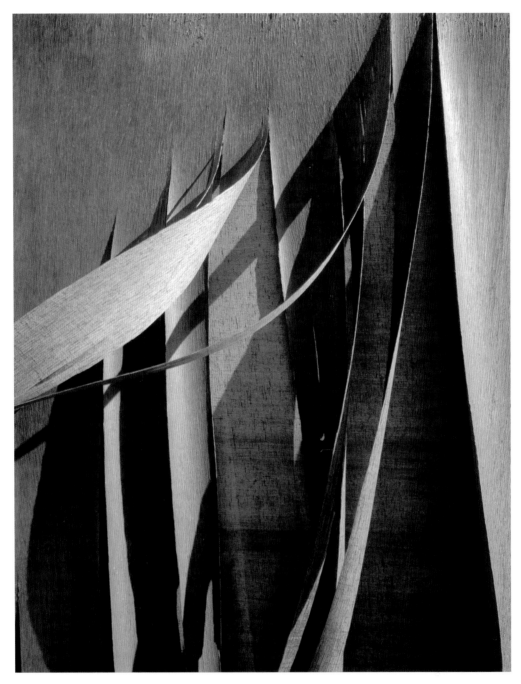

Veneer (Remains X)

Huntsville, Alabama 1982; Fuji RDP. Plaubel Makina 67

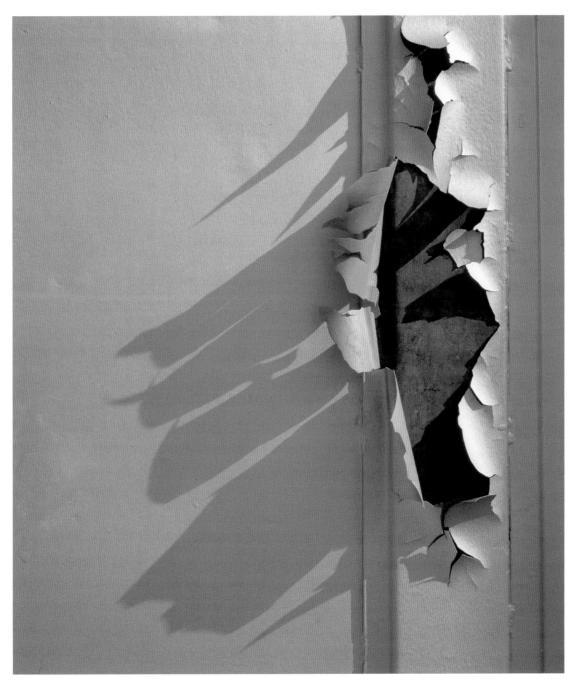

Remains III

Oberpfaffenhofen 1986; Fuji RDP. Plaubel Makina 67

Devil's rope

Normally I am not opposed to shopping; on the contrary, it can be quite enjoyable, and one can watch others somewhat callously as they try to cope with the daily hassle. Formula One racing drivers are probably less stressed in a race than these average housewives in their daily shopping grand prix – just *see* how aggressively they drive!

So it was unusual for me to stay outside a supermarket, worried maybe about all the photo equipment in the car, a little too obvious for any light-fingered passer-by. In truth, I was perhaps becoming blasé about trailing round yet another over-illuminated, hyper-cooled temple to twentieth century American lifestyle with its numbing mediocrity. The gargantuan amount of energy these emporia consume is really frightening. On the other hand, one can easily understand how they become cool havens for the less well-off in a scorching summer.

As the people hurried by, clutching their ubiquitous bulging brown paper bags, I sat engrossed in these thoughts watching a piece of white plastic caught on a strand of barbed wire. As it cavorted in the breeze like some fantasy clown, its wild dance had a mesmerizing effect – until it dawned on me that instead of looking, I should be trying to photograph it!

In McLean, Texas – 'Heart of Old Route 66', home to the largest museum in the US dedicated to the 'Mother of all Roads' – there is another Great American Heritage attraction: the Devil's Rope Museum. This showcases a unique display of artefacts, photographs and information describing the extraordinary history of barbed wire.

The name 'devil's rope' stems from the glory days of western expansion in ranching and the depressing fencing-in of America with barbed wire. As the settlement of the Great Plains grew, stockmen needed fences to contain their cattle and prevent rustling. Initially, field barriers were just large rocks and juniper branches piled together, but very soon these proved ineffective against determined cattle thieves.

One of the first fencing wires in use was known as 'Kelly's Diamond Point' patented in 1878, followed soon by literally hundreds of variants. Designs were gradually improved over the next decade or two, mainly to prevent injury to the animals. Barbed wire of any kind eventually became known among cowboys as the 'devil's hatband'. The impact it had on society in general is enormous, but its application in times of war, and in the oppression of peoples, was probably not foreseen in the beginning.

Residuals

In the early Eighties, while stationed in America, I began collecting photographs of scrap-heap objects, making pictures of things that most people recognize, even when the degree of abstraction is extreme. Perhaps the oddest, everyday motif to attract me was while waiting for a quick ten dollar exhaust pipe job on a friend's car. The mechanics couldn't see what I was going daft about in the tangled snake pit-like mass of rusty tailpipes and silencers dumped behind their tumbledown workshop.

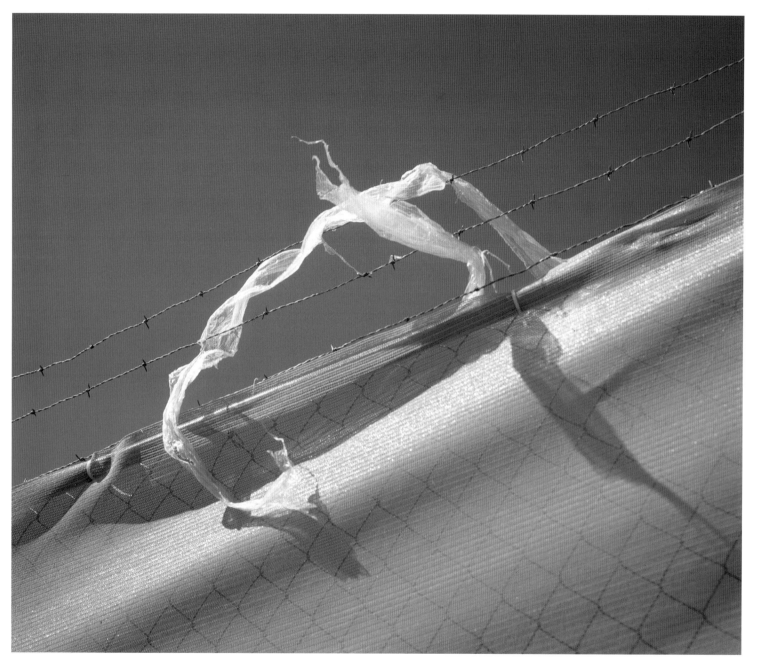

Devil's rope (Remains XII)
West Texas 1996; Fuji RDP-2. Plaubel Makina 67

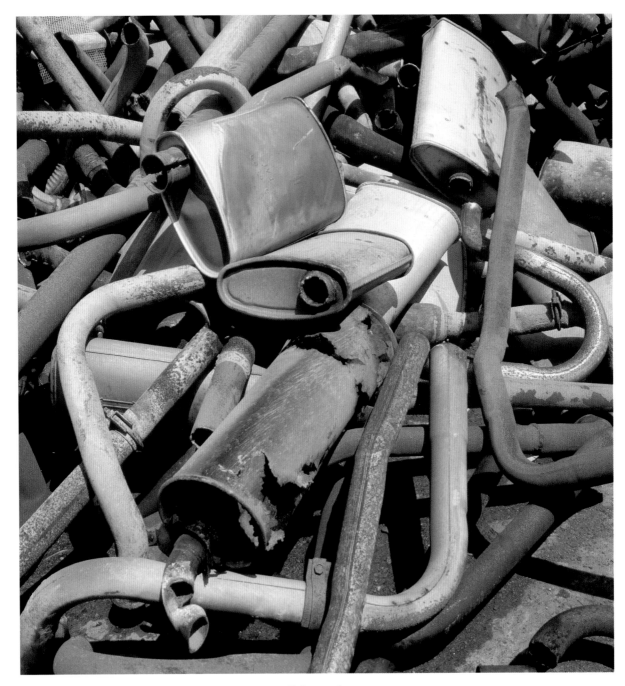

Exhausted

Huntsville, Alabama 1986; Fuji RDP. Plaubel Makina 67

Recycling in the Deep South was already 'in' at the time, and there were heaps of interesting motifs to be found by roving around the municipal trash depot. A huge cube of squashed aluminium cans, for instance, made an excellent 'guess how many' kind of picture, while a truckload of tightly packed cartons was clearly a precursor to *Yesterday's Importance*. There are similar images in my files, but none so emotive as those old newspapers.

Squashed 1982

While roaming the Tennessee backwoods, at a lonely crossroads leading to nowhere special, my journey was interrupted one day by a little general store – its false-front timber construction dating it to around World War I days.

After trying a couple of shots of an adjacent tumbledown barn, I had an intuitive feeling that there must be something else interesting to photograph in the vicinity. Then a pile of old newspapers stacked on the store's veranda caught my eye…

At first I couldn't quite envisage how to make a satisfying image out of them. Moments later, the shop owner came out to see what I was doing snooping suspiciously around the place. Her sudden appearance put an immediate damper on the idea – that magical flash of inspiration almost evaporated.

Feeling discouraged I headed for the car, the camera still on its tripod, but on the way it dawned on me what this motif really needed: a detail shot, with the lens on full extension. I dashed back to the veranda, and released the shutter just as the sun was highlighting the string around the bundled and yellowing papers. Luckily the store's owner didn't see me return.

Good fortune was with me on a second score. At normal focal distances my rapidly guessed exposure would have been OK, but in the heat of the moment I forgot to factor the time or open the aperture a half an f-stop more. This is necessary when setting a lens on its maximum extension, something that cameras with 'through the lens' (TTL) light measuring systems take into account automatically. But of the two exposures I made, only the first shot enjoyed the fleeting sunlight's full intensity.

The title of this picture, *Yesterday's Importance*, occurred to me on printing it for the first time. People always see the meaning – that today's news is often forgotten by tomorrow. I simply regret the vast number of trees used for such ephemeral purposes.

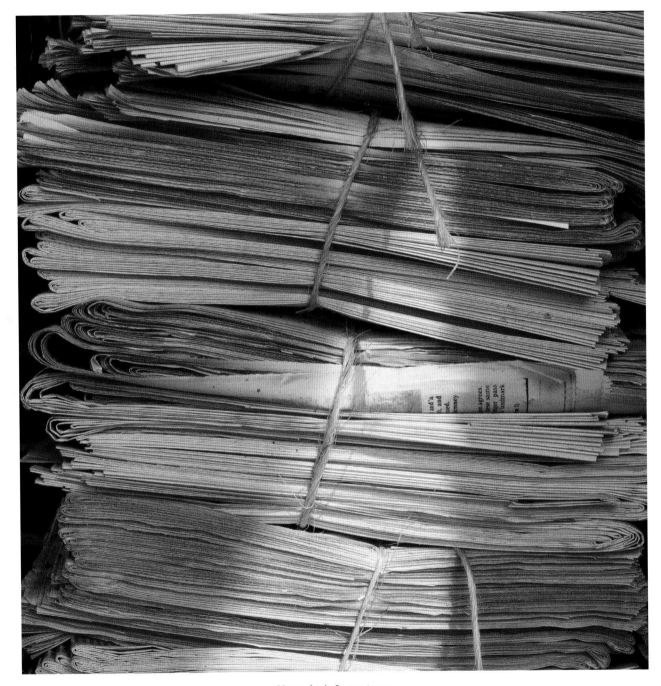

Yesterday's Importance

Tennessee 1982; Agfa R 100 S. Hasselblad 500 CM

ODDITIES

Tennessee speedsters

Early on in my Alabama residence, I took a trip into the Tennessee Smoky Mountains with a photographer friend. He said that if something caught my eye, I should shout 'stop!' In a small town somewhere along the way, we slowed for opposing traffic, coming up behind a parked truck loaded with old tyres; there was no need to shout. It was a typical Todd motif, and after a couple of quick shots with a Pentax 67 we were on our way.

Meanwhile, across the road a bunch of 'good old boys', watching my antics from the comfort of a bench outside a country store, were wondering what the heck that guy with a camera had seen in 'them ol' tars'.

Arriving at Newfound Gap we found a huge gathering of exotic Hot Rods and Street Rods in full swing. Many of these monsters had been classic cars, modified out of all recognition.

Hot Rod 1982

There were several extremes of customization on show, such as chain links welded to form a skimpy steering wheel, accessories that would never have passed our rigorous European vehicle safety tests! Others had been tailored with a flame cutter to remove about twelve inches of height round all sides, then re-welded together to form slit-windows, Chicago gangster fashion.

Some cars had open bodywork at the front, displaying lavishly chromium-plated, fearsome-looking supercharged engines with horsepower statistics good enough for drag- or stock-car racing One beautiful red-painted example was so attractive, I used almost a whole film on the wheel arch alone! As I tried various angles of view my friend's wife stood watching this with some amusement. Unwittingly, her white dress reflected in the shiny red panel, adding that extra something to one of the frames.

'Them ol' tars'

Fast car, Tennessee

Newfound Gap, Tennessee 1986; Agfa R 100 S. Hasselblad 500 CM

Try your speed

Nashville Tennessee is known as the 'capital of country music', where groups perform old and new favourites in the Opryland Amusement Park. Nashville city initially became well known nationally in 1925 through weekly radio shows broadcasting hillbilly music from the *Grand Old Opry*. It led to the development of a wide range of cowboy, country and western and swing music now popular all over the world, making many of the performers rich and famous stars.

Among the usual fairground attractions, I spotted this one for baseball fans: 'Pitch a ball and try your speed'. However, before trying one's skill, it was obligatory to don an industrial hard-hat for one's personal safety as the ball would surely rebound from the net at high speed. While a small boy waited anxiously for his go with the ball, I set the Hasselblad on a tripod as low and close as possible to make three identical shots of the coloured, plastic hardhats stacked at the side of the pitching run.

Making multiple slides this way is the cheapest and best method of having stock duplicates of any image, especially if you think (hope) it will be a sure-fire winner. Made on the same film at the same time, first generation duplicates are inherently of higher quality when compared with normal copy dupes, which always suffer some loss of definition. Moreover, if it is a really important image, the original and its first generation duplicate(s) should be kept in the archival equivalent of cold storage. *Try your speed* was shown in my 1986 exhibition at the Huntsville Museum of Art, Alabama in their 'Encounters' series aimed at presenting visual art to a wider public.

Try your luck

Scottsboro city lies on the wide Tennessee flood plain, still twenty or so miles inside the Alabama border, where the great river takes a sweeping dip southwards before looping back north again into its namesake land. It was a good place to stop for a drink on our way to and from the Smoky Mountains, though being a dry region there was usually nothing stronger than Coca-Cola on the menu.

On one occasion there was a lively county fair in progress, an event that usually includes a kaleidoscopic mix of activities, from the sale of handicrafts and all kinds of home-grown foodstuff to fancy goods and do-it-yourself hardware – while a bunch of old timers were jus' a' whittlin' the time away.

Jus' a' whittlin'

Try your speed

Nashville, Tennessee 1986; Agfa R 100 S. Hasselblad 500 CM

Try your luck!
Alabama 1982; Agfa R 100 S. Hasselblad 500 CM

Naturally as in most fairs, there was a fairground carousel, candy stalls and lots of kitsch, including some disturbing collectables such as German army helmets, Iron Cross medals, swastikas and other wartime memorabilia. Amongst all this stuff was a classic, one litre German beer *krug*, filled not with the kingly liquid for a Bavarian sized thirst but American greenback dollar bills. The aim was to guess how many dollars were in the dimpled glass, which conveniently distorted the values.

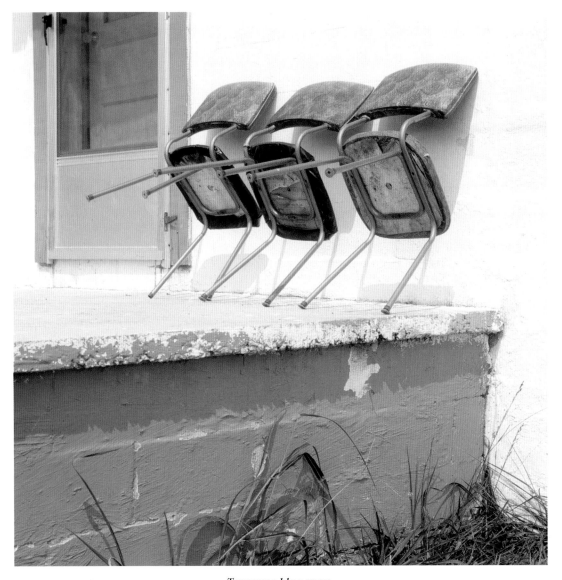

Tennessee blue grass

Tennessee 1983; Agfa R 100 S. Hasselblad 500 CM

On one of my last trips around the Tennessee borders, I saw something which will always remind me of the Deep South – a typical bungalow porch with three chairs turned facing the house wall. Approaching the house with some apprehension, I tapped on the storm door to ask the bemused owner if it was OK to photograph his old chairs. 'You what? You wanna take a photo of them ol' chairs?' He thought I was kidding.

CHAPTER TWO
Pictorial Pieces

The *Concise Oxford English Dictionary* defines pictorial as: '/ pik'tor ial / adj. & n. · adj. of, or as expressed in a picture. · n. a journal, postage stamp, etc., with a picture or pictures to illustrate a feature'. To my way of thinking pictorial, as applied to photography, could embrace just about anything – a still life, landscape or person – depicted in the way artists do, and it doesn't have to be in colour to qualify as pictorial.

Some straight documentary work could be grouped under the general heading of pictorial. W. Eugene Smith's narrative studies of Spanish village life could well be regarded in a pictorialist framework. There are many examples in portrait photography: works by Karsch, Gibson, Penn or Snowdon, verge on pictorial by the settings used, or a mood conveyed.

Historically, pictorial photography (as it mostly was in the beginning) was reviled in fine art circles. Reviewing Louis Daguerre's invention for a French national committee, Paul Delaroche had even declared: 'From today painting is dead.' Taken out of context, it set photography off to an odd start. After an initial love affair with its quasi-scientific aspects, many nineteenth century devotees of photography turned to pictorialism as typified by the grandiose allegorical works of Henry Peach Robinson and Oscar Rejlander *et al.* – and the Victorian public loved them!

Together with George Davidson, Peach Robinson formed The Brotherhood of the Linked Ring whose stated aim, in an opening manifesto, was to show that 'through the salon... pictorial photography is able to stand alone and that it has a future entirely apart from that which is purely mechanical'.

They imitated fashionable genre paintings to further their cause, an approach vigorously rejected by another Linked Ring member, Peter Henry Emerson. In his book *Naturalistic Photography* (1889) advocating a return to honestly represented natural scenes, Emerson deplored methods used by some pictorialists such as painting over or cross-hatching on their negatives, barbaric methods to achieve a painterly look.

Pictorial protagonists emulated the Romantic Pictorialism movement in academic fine art painting with soft, or out-of-focus methods – which had been advocated by a painter of note, Sir William Newton, in 1853. Some, especially Emerson, even suggested that this was how a photograph should represent things, because at any given moment we tend to look at one part of a scene while the rest is not sharply focused.

All perfectly feasible – except that this was not what real artists did on their expansive landscapes, or full length portraits. The portraiture of Julia Margaret Cameron evinced this style, however, with blurred images of famous men, and her later allegorical pictures influenced by the Pre-Raphaelite painters.

The Pictorialist movement quickly spread to America where, among many others, Gertrude Käsebier, F. Holland Day and Clarence H. White took up the pictorial challenge, while Holland Day's cousin Alvin Langdon Coburn and Edward Steichen led the impressionistic soft-focus school. In 1902 Alfred Stieglitz formed a group called the Photo-Secession with similar aims to the Linked Ring brotherhood, though Stieglitz himself did not share their penchant for image manipulation.

Ultimately they saw that this was not the way to gain recognition as artists. Photography had to be accepted as legitimate art without recourse to artifice and subterfuge. Fuzzy pictorialism finally succumbed in the early decades of the twentieth century to the sharp focus and realism of the American west coast Group F-64 photographers, including Imogen Cummingham, Ansel Adams, Willard van Dyke and Edward Weston. Improved camera equipment and films contributed further to this development.

As a movement, Pictorialism was submerged in the general advancement of photography along with new modes of artistic expression explored after World War I. New Objectivity and Expressionism, and the surrealist styles of the German avant-garde, the Bauhaus intellectuals, architects, artists and photographers in the Twenties and early Thirties – they all changed the way we look at photographs.

Pictorialism is still as strong as it was a hundred years ago when it was pursued by a more elitist group of artists. It has remained the domain of monochrome fine art specialists working independently, or with its devotees in photo clubs. Now a new form of pictorial art is rising with today's photographers creating electronic images just as exciting as their silver-halide forebears...

A good example of a picture telling a story is the one opposite, seen just a short distance from my own door. Bavarian village communities pride themselves in having the tallest and best decorated maypole in the area. The pole is usually replaced every four years and the old manual way of hoisting it is quite a performance – one the whole village turns

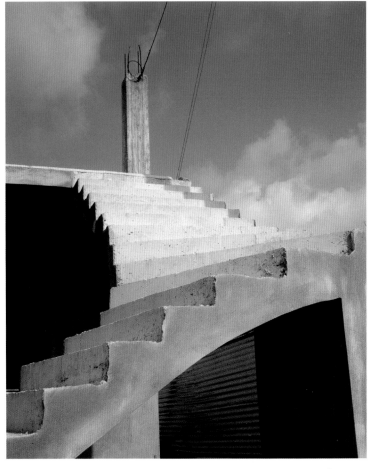

out to watch. There is still a tradition of stealing the new pole, so in the run up to May Day our volunteer firemen keep a round-the-clock vigil guarding it against a neighbouring village's likely lads. If they do manage to purloin the pole, a sizable ransom is paid – usually roast pork and beer all round – to secure its timely return.

to be continued

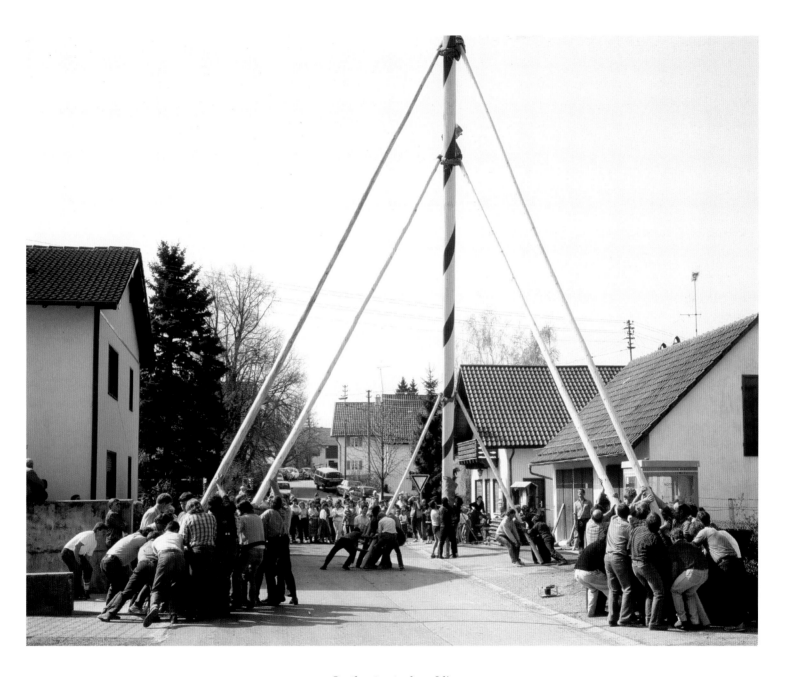

On the street where I live

Hochstadt, Bavaria 1987; Fuji RDP. Plaubel Makina 67

STREET SCENES

As suggested in my opening, pictorialism is not just a cover-all term for 'nice pictures' of pastoral scenes. Any picture that tells a story can be called pictorial and many of the following would fit this description. To qualify as pictorial, however, an image doesn't have to be in colour, though it does add that extra lifelike dimension where street scenes are concerned. Naturally, behind the visual story are other stories, volumes waiting to be told: the local history, facts and figures, or one's own feelings about the place or motif.

Some of the most evocative images are to be found in a quiet village lane or on a bustling city's streets – pictures that can convey, in an instant, the heat (or cold), the sounds and smells of a Mediterranean metropolis. There is such a plethora of sights in some of these places that one could well believe it has all been arranged just for photographers. Motifs range from balconies laden in tiers with washing and flowers, graffiti-spattered walls and sinister alleyways, to shop doorways stacked invitingly with fruits and vegetables or pots and pans.

There is the gamut of humanity out there too if you specialize in the candid camera type of photography. This is not new; many pioneer photographers went to extraordinary lengths to get unposed portraits of people unobserved, using a mirror or prism built into the lens barrel. Paul Strand made a few of his famous New York street pictures using a camera with a false lens on the side to distract attention from his real aim. Others hid a pre-focused camera under an overcoat to get pictures by subterfuge through an unbuttoned opening, a trick I have also used in places where photography was not officially allowed.

Street photography is where a small 35 mm camera can really excel. But while a majority of today's photographers prefer to use a single lens reflex (SLR) camera, many of the great masters made their mark in photo-reportage with rangefinder types such as the Leica or Contax. One thinks of Henri Cartier-Bresson or Brassaï, for instance, both famous for their candid photography in the streets of Paris. Brassaï's best work was done in the risky night-time world of Montparnasse alleyways or café-bars redolent of images like those of painter Henri de Toulouse-Lautrec. It was bread and butter work for some, artistic statements for others.

With its almost noiseless shutter, my tiny 35 mm Petri is ideal for covert snapshots or fun shots aimed over the heads of busy crowds, or of people behind my back – or simply hung out of a stationary bus window as I did once to shoot an appalling traffic block in smoggy Athens.

My other favourite camera for informal or candid photography is a vintage Plaubel Makina 67. I've used it on occasion slung sideways over my shoulder – the shutter set to 1/500th second, stopped down to f-8 and focused at 5 meters – to snap an unsuspecting party while slowly walking past, pressing the button at the appropriate moment.

This method has worked for me in Greece for example, where those classic tourist brochure images abound: weathered fishermen or black-garbed priest sitting quietly outside a bar – though admittedly it's unfair to steal snaps of them this way. They clearly don't like strangers pointing cameras at them; one can see this in the way their faces are immediately averted. Wouldn't you do the same…?

That distinct fin de saison *feeling*

Vicenza, Italy 1983; Agfa R 100 S. Pentax 67

Sunday mornings

Though I've said elsewhere that people pics are not really my *métier*, it is difficult to resist the scenes in a typical Italian square or piazza, especially on a Sunday morning. On one such day in Vicenza, with that distinct *fin de saison* feeling in the November air, I watched fascinated while a group of men volubly discussed the latest political theme, or their football team's exploits.

They were standing like actors in some staged scene, normally difficult to arrange in a group photograph. I shot this cameo from a discreet distance, using a long focus lens on a Pentax 67, the noble columns of Palladio's Monte de Pietà serving to hide me and support the big reflex camera during its cataclysmic shutter release.

There is really little to date this image; the men are dressed in a style popular almost seven decades ago. Their smart fedoras lend a timeless atmosphere where nothing seems to have changed since before Mussolini's time – except that politics can now be debated actively on the streets. Occasionally there is some part of a photograph that holds one's attention; someone looking straight into the lens, something odd to focus on, like the seemingly detached hand outstretched in the middle of this group. A man's white braces forming an 'X' in the middle of Stieglitz's *The Steerage* has the same effect.

Autumn is a good time of year for my nostalgic genre of photography, the kind one finds in Italy or France early on a Sunday morning. The sun is low in the sky, modelling the shapes of things better, while shadows are thin and long, the empty cobbled streets slippery wet with dew and there are lots of shiny highlights.

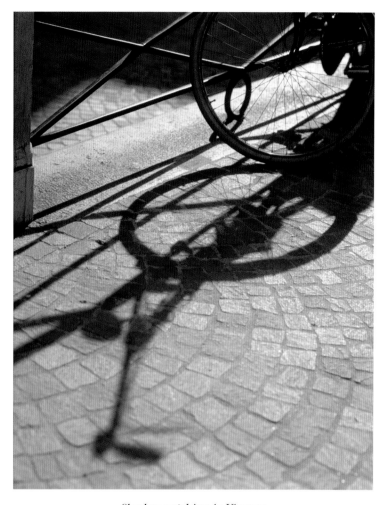

Shadow catching in Vicenza

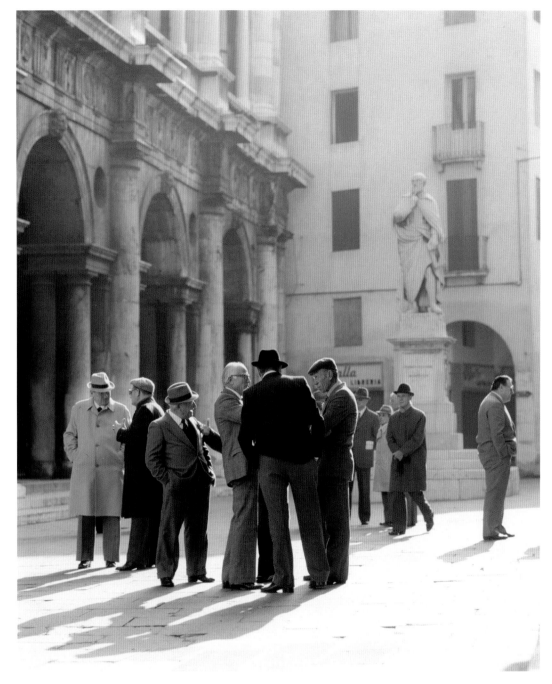

Politics, politics...

Vicenza, Italy 1983; Agfa R 100 S. Pentax 67

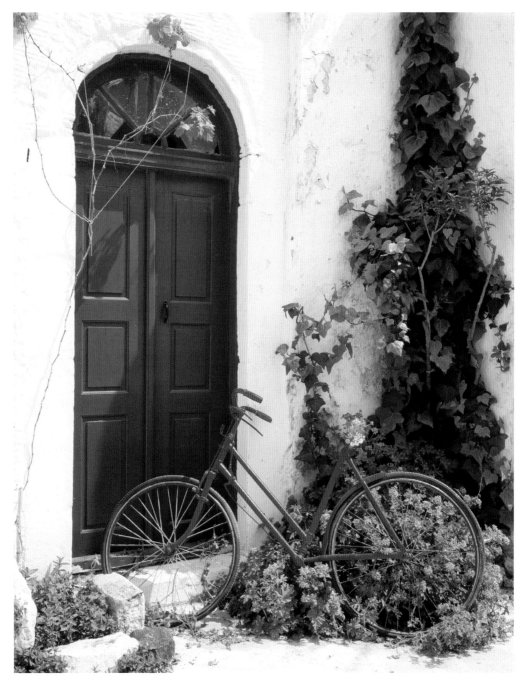

Red bike

Paros, Greece 1985; Fuji RDP. Plaubel Makina 67

More street scenes

The picturesque streets of Paros gave me dozens of images that could easily be categorized as pictorial, graphic, or simply 'nice'. Not only that, all the motifs I came across seemed to have been arranged especially for photographers. That red bicycle, for instance, had probably been parked for some long time outside the house; the flowers growing through the wheel spokes showed this. It was in a narrow side street in shadow, but judging from the aspect I guessed that the sun (almost at its equinox) would probably shine into the street an hour or so before midday – and hoped the bike would still be there the next day.

A few years later, while running a photo workshop on another island far removed from the Cyclades, I spotted a postcard of the identical motif: the Paros bike – except that there were no flowers in the saddle-stock. Judging by the format and composition, it had been photographed from a slightly different position, most likely with a 35 mm camera. Clearly I was not the only one to have fallen for this motif, which was probably set-up by some kind person who knew what photographers like to see; but who put the flowers there? Not me, sir, honestly!

Where the rainbow ends

Somewhere in small town Alabama, I wandered down the sort of back lane where one usually saw a forest of power and telephone line masts and abandoned cars. This back street was different and obviously cared for. In a row of typical white clapboard commercial buildings, the wall of one had been decorated with a panorama of butterflies and bluebirds flying above a rainbow over a doorway.

The entrance to a dentists' surgery, it was clearly designed to make a child's visit less terrifying. Perhaps the 'torture

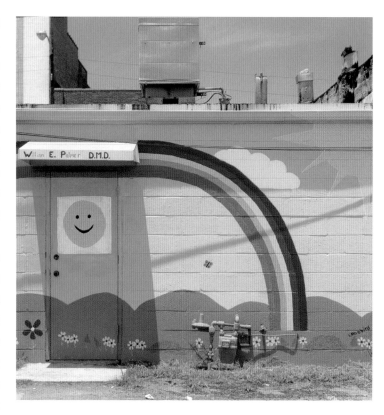

chambers' within were similarly decorated, as in my local dental practice.

The rainbow is a symbol of happiness to many people. Children still love Oz, the fairytale land inhabited by scarecrows, tin men and wizards. Rainbows are respected in many different cultures in a variety of forms and deities. Christ is sometimes depicted seated on a rainbow throne, whereas in other cultures it forms a bridge between mankind and the gods.

Irish folklore says there is a pot of gold to be found at the rainbow's end, but right under the end of this painted rainbow, and chained to the surgery wall, was an archetypal galvanized ashcan. Another friendly set-up for photographers, I wondered?

Where the rainbow ends
(does this make me a member of the Ashcan School?)
Alabama 1982; Agfa R 100 S. Hasselblad 500 CM

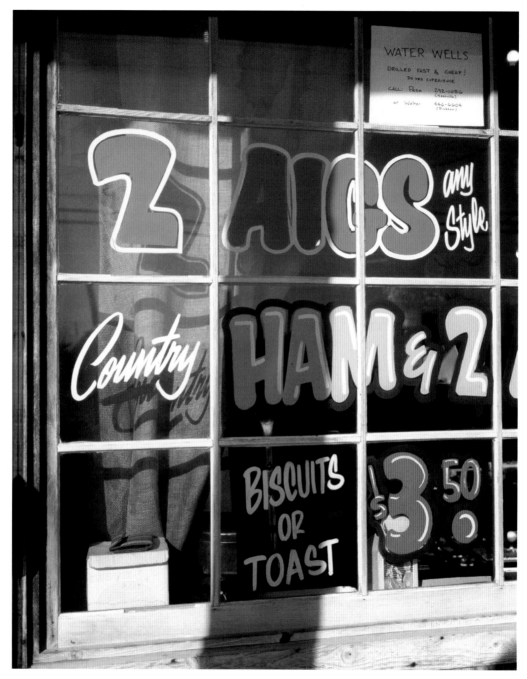

2 Aigs, any style!

Tennessee 1983; Agfa R 100 S. Plaubel Makina 67

FRONTIERS

Looking beyond

Doors, windows and mirrors are more than just wood, metal and glass. They are frontiers to a rich source of motifs limited only by one's imagination, portals to the world beyond their thresholds. A door can be a gateway to chance meetings, new friends or a new job. Some stay mute and forbid prying eyes with notices like 'Keep out', *'Eintritt Verboten'* or *'Défense d'entrer!'* A window can recall tranquil days at the old smithy when horses were a means of transport rather than playthings of the well-to-do – or show us things like a Tennessee family diner's tempting offer of '2 Aigs'.

Calendars, postcards or coffee-table picture books of the Greek islands, showing brightly painted windows, doors and timeworn stairways, are likewise clichéd reminders of holidays spent roaming the blue Aegean for most people. But for me, a broken pane of glass stuffed with newspaper is far more evocative of the place and the taste of garlic-rich tzatziki, retsina and sun-ripened fruit. Typically Mediterranean, it was probably enough to keep out bad weather.

Not that it rains much in Naxos, the popular Cyclades island where the already pregnant Cretan princess Ariadne was abandoned by Theseus, after helping him find and kill the Minotaur. She then married Dionysus, god of wine, who just happened to drop by on Naxos, setting an unhappy precedent for young lovers well over two millennia ahead of their time – and providing the basis for a twentieth-century opera.

This picture could be a show stopper in a mixed media installation, with real lemons tumbling out of the picture, and a few scattered on the floor. Maybe a strong smell of garlic too...

Shoshone window

One late December day in '81, while driving along National Route 95 near Shoshone, heading to the mountains on the Nevada-Californian border, my attention was taken by a number of small holes in a low sandstone bluff – caves of any kind attract me like a pin to a magnet. Cautiously approaching one of the entrances I was surprised to find it occupied by an elderly man, tidily dressed and well spoken, perhaps not quite one's idea of a cave-dweller. Some might have called him a hermit...

He was enjoying the setting sun sitting in front of his home-sweet-home which was quite an eye-opener. Spick and span inside and looking very comfy, it was furnished with a spring bedstead and upholstered armchair, all neatly arranged on a wooden-boarded floor. Wires suspended along the brick lined walls were used for hanging clothes and to store food in plastic bags out of reach of creepy-crawly things. A single oil lamp gave enough light to read a good book. 'Not much room' he reckoned, 'but enough, if you don't have the acquisition bug.'

Nearby, a curious nondescript shack, with massive sheet metal walls brightened up by Sixties flower people decorations, made several attractive additions to my growing collection of Americana images. The windows inside were covered with aluminium foil, probably to shade the occupants from the blazing desert sun – or prying eyes like mine. Though it appeared to be abandoned, one can never quite tell; it's said that some folks shoot first and ask questions afterwards!

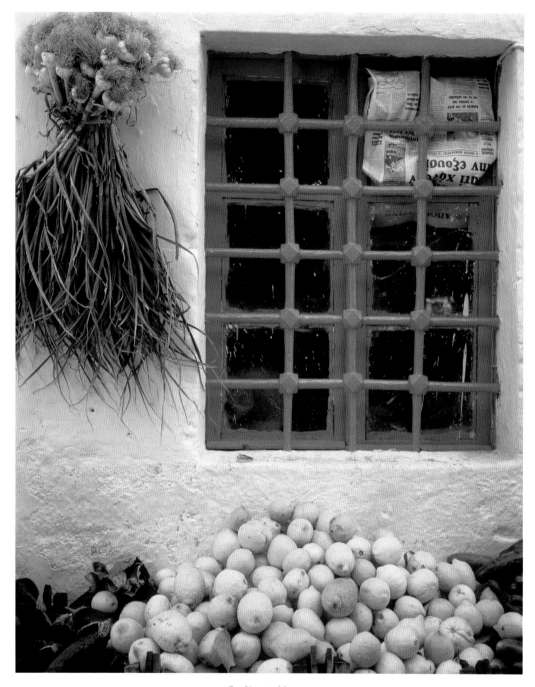

Garlic and lemons

Naxos 1985; Fuji RDP. Plaubel Makina 67

The old smithy, 1979

Mammendorf, Bavaria 1979; Kodak KR 64. Hasselblad 500 CM

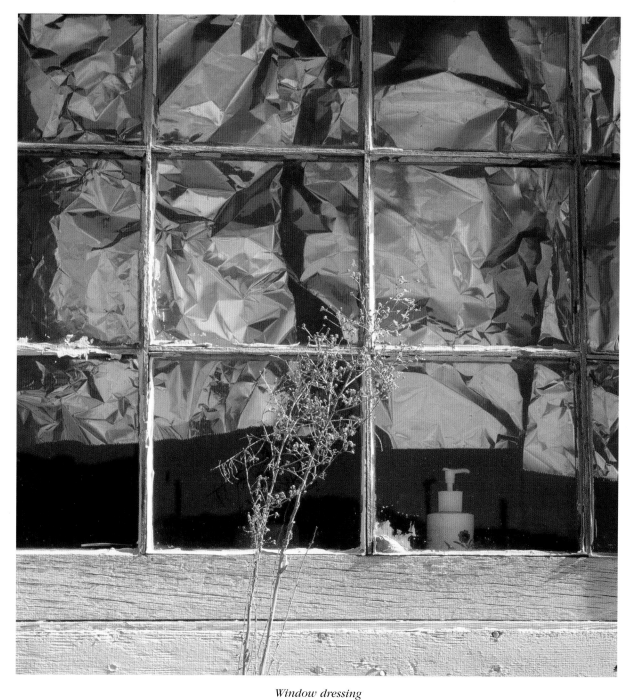

Window dressing

Shoshone, California, 1983; Agfa R 100 S. Plaubel Makina 67

Mirror, mirror…

When Charles Lutwidge Dodgson, mathematician, logician and photographer asked a little girl named Alice to stand before a mirror, and say which of her hands held an apple, she saw that it was the reverse of reality. She turned to ask him: 'Which hand would it be in if I were on the other side of the mirror?' It was a simple question that resulted in *Through the Looking-Glass*, penned by Dodgson under the pseudonym Lewis Carroll.

I have often wondered about this 'other side'. The mirror may well be on a wall, but where are you? Is that *doppelgänger* really you? To illustrate this, have someone trace a soapy finger around your *virtual* mirrored image. It's about the size of a grapefruit…

Alabama hangovers

On one of my first photo outings south across the Tennessee River, a little bric-a-brac shop somewhere in Morgan county caught my eye, especially a pair of washstands with mirrors reflecting nothing but the bright gravel behind me. By contrast, the shop window was a confusion of colours and reflections.

As I began to compose the image in the viewfinder, two children appeared mirrored in one of the washstands. They had been watching me from behind and were presumably heading back into the shop. Without turning, I shouted 'hold it' and held up my hand – momentarily scaring them, for they literally froze on the spot. For some still obscure reason I quickly adjusted the Hasselblad downward so that their heads were not in the mirror's image, then made three rapid exposures before they tired of waiting. To round off the impromptu entertainment, I made a happy family group picture…

Several months later, I took a small print to show them how their pictures had turned out. The two little girls were not at all impressed with the results; they had been tricked out of their photos. Sadly, the group picture had already become a record of 'how we were'. The parents had meanwhile separated, though the kids seemed to have taken it all for granted – a sign of the times.

A Cibachrome print of *Mirror trick* was purchased by The Museum of Art Huntsville, Alabama on the occasion of my first American exhibition in 1986, and has since been published in the Hasselblad house magazine and several other prestigious photo magazines. A black and white version made via Agfa inter-negative material is just as effective as the original colour image.

Mirror trick

Alabama 1982; Kodak KR 64. Hasselblad 500 CM

Pioneer windows

The label ghost town is probably less accurate today than it was sixty years ago, when so many towns scattered around the American Southwest were quietly decaying into ruins. Many had been centred on raising stock and farming foodstuffs, communities that suffered badly and never really recovered from the great depression of the Thirties; some settlements disappeared without trace. Others were busy mining centres that faded when the mineral resources were exhausted, or a hoped-for railway connection was not built.

In Chloride, Arizona, I reminisced in a bar with some of the locals about the glory days between 1910 and 1920, when silver chloride (the rock mineral that gave the town its name) was mined along with gold, lead, copper and turquoise. At its peak, the population was around two thousand and the miners were being paid three dollars per hour working a twelve-hour shift. Over forty individual mines were scattered around the locality.

A leading mine, the 'Tennessee', had produced some seven million dollars worth of gold before it closed in 1948, though the majority of that astonishing output was made early in the twentieth century. In its heyday, Chloride's town district had covered three blocks, and included all the usual commercial buildings. Besides banks, the company store and a post office, there were several saloons and 'houses of other pleasures'.

As I strolled down the middle of a deserted main street, it really did feel like a ghost town. Even the old railway depot was a forgotten shack in a grass-covered siding, where the rusting terminal rails were bent significantly toward the sky, like some dead animal lying belly up in the dust.

Many of the old buildings including the post office and the small city bank were still standing. With a rocking chair on its classic log cabin porch, the bank looked more like an archetypal Western film set, triggering fantasies *à la* James Thurber's

In a grass covered siding

daydreaming hero in *The Secret Lives of Walter Mitty*.

The corners of the bank have been cropped in this print so there is no clue to its size; it was actually only a little bigger than what is seen here. What I liked about this motif was a bottle of milk on the inside window ledge – it was probably completely fossilized! Goodness knows how long it had stood there in the Arizona heat.

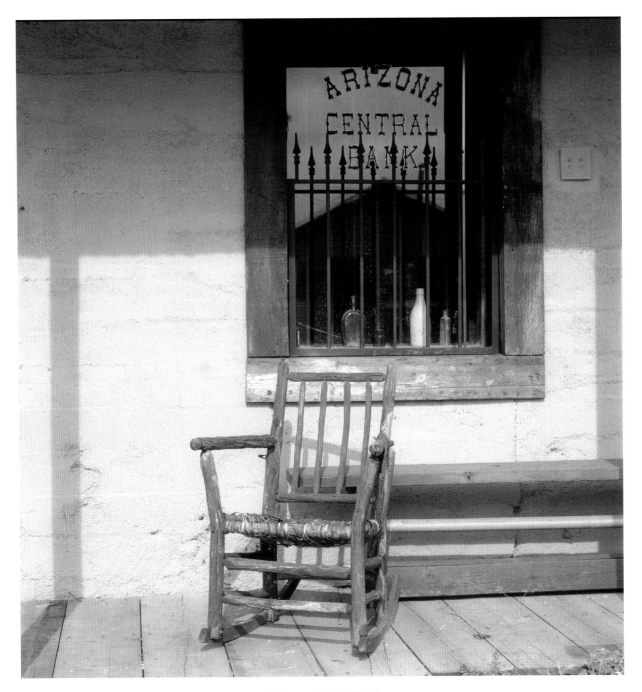

Arizona Central Bank

Chloride, Arizona 1983; Agfa R 100 S. Hasselblad 500 CM

Windows of a third kind

About 2000 years ago, in what we now call the American Southwest, groups of nomadic hunter-gatherers began to blend together. They became settled farmers and architects of a remarkable civilization that flourished in numerous villages scattered around Four Corners region for almost a millennium. Native Americans still call them the *Old Ones* – the Anasazi.

Excavations in north-western New Mexico indicate that by the tenth century, a centralized society was thriving in the region. The main site in Chaco Canyon, Pueblo Bonito, was a veritable capital with several satellite towns forming the eco-political centre of the Anasazi world. They built a 600-mile network of roads radiating with Roman directness from Chaco, connecting neighbouring populations such as those at Salmon and Aztec Pueblos up to fifty miles away. But with no form of wheeled transport, why did they build roads? Some think these trails were more for ceremonial purposes, than for trade or traffic.

The extensive ruins at Chaco lie in and around a shallow 15-mile-long canyon where a mostly dry *arroyo* winds through the scrubby landscape. While several of the major pueblos have been excavated, and are accessible to the public, a majority of the 2400 known sites, possibly the richest source of pre-Columbian archaeology in North America, are still unexplored.

Despite the advances made in agriculture, the Anasazi culture seems to have faded by the mid-thirteenth century. A dry spell lasting half a century is thought to have contributed to its collapse. In what is essentially a desert region, such a drastic drop in rainfall coupled with over-exploitation of natural resources, particularly firewood, would have been catastrophic. In our own times we have seen the awful effects of just a few years of drought in Africa, but fifty years with very little water is almost inconceivable.

Whatever it was that led the Anasazi to abandon Chaco, it is thought they dispersed southwards – some say the Anasazi and early Hopi tribes were contemporaries.

The Anasazi were highly creative and left ample evidence in fine ceramics, murals (pictographs) and petroglyphs scattered throughout the American Southwest. They were great builders too. The Great Kiva of Casa Rinconada and Pueblo Bonito in Chaco Canyon with ingenious corner windows – some devised as seasonal markers – are witness to these skills. New studies in archaeo-astronomy (a science pioneered at Stonehenge, England and other European megalithic sites) have firmly established the use of astro-timekeeping by the Anasazi. Back in the Seventies, the transit of a solar equinox through a notch in accurately placed rock slabs was filmed high up on Fajada Butte in Chaco Canyon.

A friendly word of caution regarding Native Indian kivas is appropriate here. While photography on State or National Park sites is generally encouraged, even welcomed, never, *never* try to photograph or enter a kiva in a living, occupied pueblo. The sanctity of a kiva demands absolute respect; it is strictly off limits.

Many pueblos have imposed a total ban on recording of any kind (photographing, filming, painting or sketching) either in the villages or out on the reservations, mandatory rules that still apply in many places. Dare to contravene, and you could lose your treasured camera! There are several excellent books on the Pueblos that include details of the pueblos that do not allow visits of any kind, or those that do after appropriate payment according to a fixed tariff.

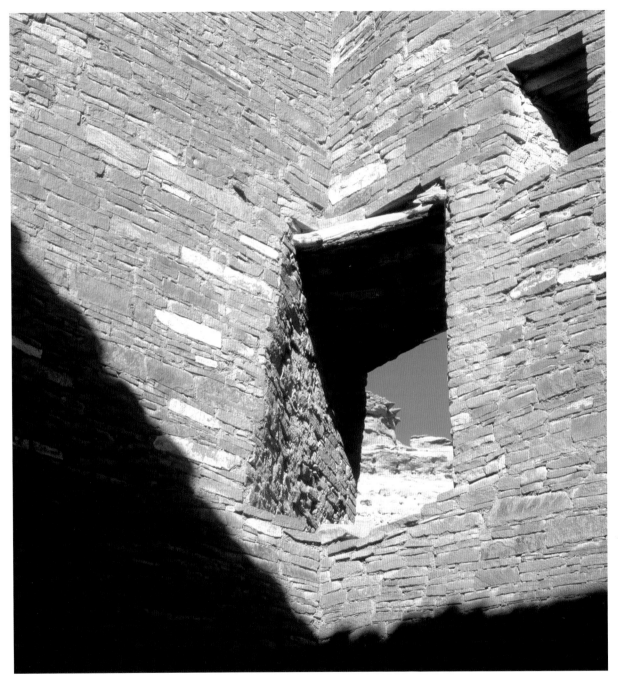

...ingenious corner windows

Chaco Canyon 1991; Fuji RDP-2. Plaubel Makina 67

DREAM STUFF

Awaiting Casanova

Venice, say the guidebooks, is a great romantic city of sinking islands, labyrinthine waterways and fading Renaissance glory. Of that there is no doubt. Its unique atmosphere moved generations of artists and composers to produce major works. Photographers revel each year in the colourful Carnival masquerade in the grand Piazza San Marco, overflowing with tourists, squadrons of fat pigeons and photo-vendors with their ancient wooden cameras. Visit it if you can, at least once in a lifetime; no theme park lookalike could ever compete with the real thing.

Summer finds Venice bursting its noisome seams with tourists, while espresso bars, restaurants and gondoliers work overtime – and love every minute of it. This is the familiar face of Venice: the busy streets, canals and magnificent palace buildings so accurately portrayed by the eighteenth-century Italian painter Antonio Canale, otherwise known as Canaletto. His still-popular paintings have an uncannily realistic, almost photographic accuracy and quality. Little wonder, for it is said that he sketched on-site using a *camera obscura* – an imaging device going back not just to his time, but a *couple of thousand* years ago, to Aristotle. Canaletto's device may even have had a mirror to put the image right-side up, a precursor of twentieth-century reflex cameras.

There is another, more hauntingly beautiful aspect to this great city of sea and sky – the Venice of late autumn, when it is transformed to a dreamy vision that inspired the Impressionists. It is the time of year when sea mists come rolling in fogging the views; the season when the canals fade in melancholic greys and the *calle* become shadowy canyons as dusk falls, when the lagoon in full moonlight is more a fantasy than real...

This was how I saw Venice on a quiet Christmas Eve, and even as the *vaporetto* disappeared into midday mists, the magic began to work. Barely a minute after setting foot on the slippery wet landing stage, an image leapt straight into the camera's lens and with one shutter-click, the very essence of Venice had been distilled in silver halide.

It is a typical pictorialists' view of ochre-coloured palatial buildings lining the historic Grand Canal, complete with the ubiquitous gondola moored in the foreground. But despite it being a snapshot I remember fretting about an untidy forest of mooring poles in the middle-distance, then deciding to position the gondola's prow in the confusion of tall sticks – a kind of 'can't beat 'em, join 'em' move. In retrospect it might have been better to have hidden the poles behind that prow.

In the tourist seasons, the Bridge of Sighs, the Rialto and the dimly lit canal sidewalks normally throng with people, but on Christmas evening they were almost deserted. Then *Awaiting Casanova* appeared out of nowhere while crossing one of the many smaller bridges somewhere in the old city.

Lodging the camera on the wooden parapet, which seemed to be moving slightly, I remember thinking: this is ridiculous, a daylight colour film, exposing it in the evening gloom, when the only illumination is a distant street lamp. Undeterred, I set the shutter to 'B' and held it open while slowly counting to five, then counted one more for luck. Halfway through this somewhat arbitrary exposure, a *vaporetto* swept into view to disturb the tranquil water. I thought nothing more of this episode until the film was developed.

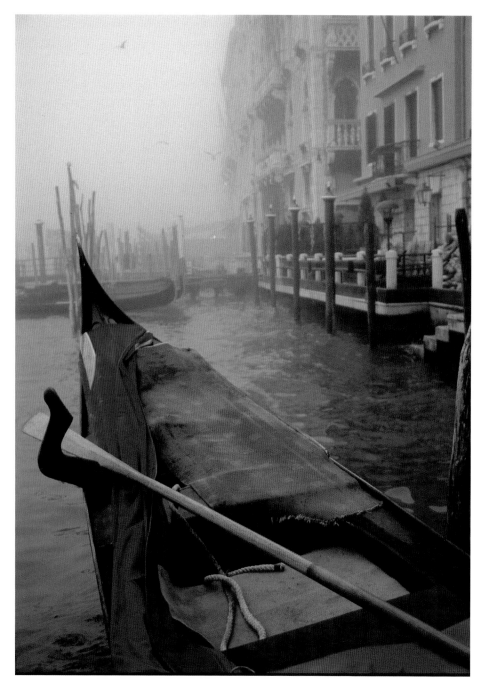

Venice 1

Venice, Italy 1984; Fuji RDP. Plaubel Makina 67

As could be expected, the *vaporetto*'s headlights had left two yellow streaks in the image, distant tracers mirrored in the canal. But why, or how the shades of twilight turned out to be such a fantastic blue is difficult to explain; it certainly had nothing to do with filters, or the type of film – just another silly shot that didn't work out as anticipated.

One day while experimenting with this image, inverting it to improve the perspective, I raised the enlarger head to crop out the *vaporetto*'s headlights. Then I saw that lone illuminated window, which prompted the title: *Awaiting Casanova.*

During another Cibachrome printing session a few years later, the original left-hand side of this 6 x 7 cm image yielded another even dreamier, slightly unsharp image of Venice – two pictures from one transparency.

By the way, if you can keep a secret, below is what the original transparency (Fuji RDP) looks like.

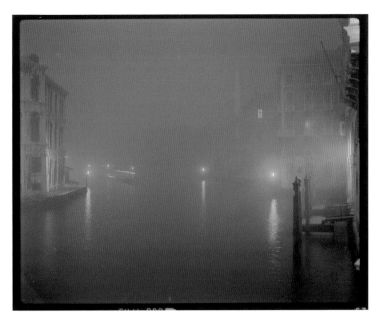

Venice, December 25 1984

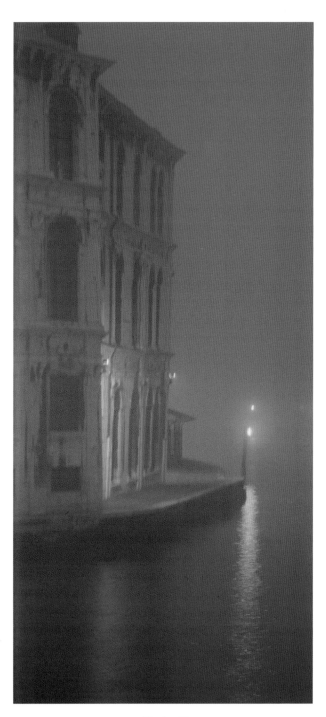

Venice V

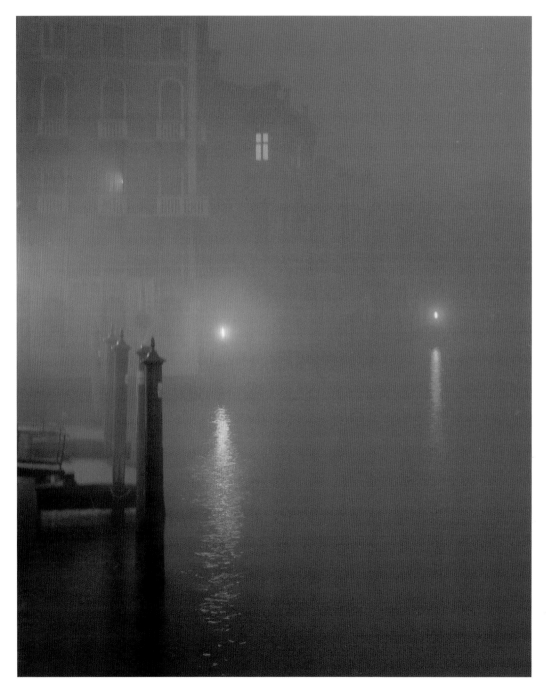

Awaiting Casanova

Venice, Italy 1984; Fuji RDP. Plaubel Makina 67

Fantasy castle

In the Bavarian mountains near the town of Füssen, there is a monumental piece of one man's dreams that didn't come true: the famous castle of Neuschwanstein. Associated with this extraordinary edifice is a double irony, however.

First, Ludwig II lived in this incredible castle only briefly before he was arrested by a government sick and tired of his reckless spending on such projects, accusing him of misappropriation of public funds. While the case was being investigated, he and his supervising doctor were found dead near the family castle at Berg mysteriously drowned in the waters of Lake Starnberg.

Here the Bavarians lost their king

Secondly, although he built it high on a mountain to be alone with his fantasies, it is now Germany's most visited tourist attraction. Currently, the number of visitors runs to millions annually, and is still rising. Tours to the castle have had to be limited to a daily quota. Part of this immense popularity can be attributed to films, such as various settings of a romance between Ludwig II and cousin Sissy.

Another popular boost to the castle was *Chitty Chitty Bang Bang*, a fantasy story by James Bond author, Ian Fleming. There were two real Chitty Bang Bangs (Fleming added the second 'Chitty'), famous racing cars built by Count Louis Zborowski. *Chitty I* was powered by a Maybach 23-litre 300 hp aero engine and clocked 120 mph at Brooklands, where it crashed in 1922. The original *Chitty I* was scrapped in the Thirties.

The last time I climbed in the craggy mountains behind Neuschwanstein some 3500 ft up, I took the more exciting way down a sheer limestone cliff named the Yellow Wall, pausing at the top to snap a sign 'Danger of Death' – stark warning for inexperienced hikers not to venture any further. Yet some do.

After this enlivening section, a long slog down a seemingly endless serpentine trail finishes in the green fields below, where nowadays paraglider folk assemble after their much easier method of decent. Back at my starting point, I looked up to see Ludwig's castle in the rising mists of early evening looking more like the fantasy castle of his dreams.

This is the oldest image in the book, made with a long focus lens on a Steam Age Canon F1 and Kodak KR 64 film in 1977.

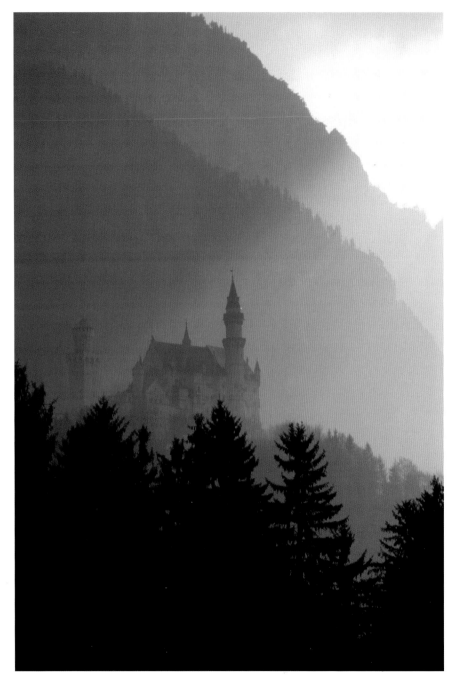

Fantasy castle

Neuschwanstein 1977; Kodak KR 64. Canon F1

INSIDE STORIES

The old trader's bedroom

The Hubbell Trading Post is one of the oldest, continuously operating enterprises of its kind in the USA. Now a National Historic Site, it is administered by the US Parks Service. Situated on the Navajo Reservation at Ganado in the north-east corner of Arizona, it has changed little since the days when it was a centre of trade and contact between native and non-native communities.

John ('Lorenzo' to his Hispanic friends) Hubbell was well respected among the Indians, and often functioned as a link between tribal elders and government agencies, especially when it came to education and medical care programmes. During the smallpox epidemic of 1886, Hubbell personally tended the ailing Navajos, gaining their trust and enduring love, his medicine and healing skills being ascribed to supernatural powers.

Hubbell had demanded the highest quality of work, and encouraged the Navajo weavers to develop new and colourful designs that eventually became a Ganado hallmark, making it a byword in the world beyond the reservation. It also became a popular meeting place for the Navajos, especially in winter when they could enjoy the warmth of a wood stove, as well as trade goods. Exchange and barter was not new to the indigenous folk; trading had taken place between tribes for centuries before the strangers came. The difference was the *kind* of goods they had to offer. With a home bakery producing several hundred loaves each week and a farm with all kinds of livestock, the trading post was more than just a local merchandise store; it was practically a self-supporting settlement. There was also a smithy and even a school – when a teacher could be found to run the classes.

When I arrived there in January of '84, it was late in the afternoon with the sun already low in the sky – but there was still enough time for a brief tour of the family home. The old trader's bedroom was richly decorated with period prints of proud Indian chieftains, some of them original turn-of-the-century works by the pioneer photographer Edward S. Curtis, criticized by some for his over-romanticized images of Native American Indians. This is unjust, for they are some of the most sensitive portraits of Indians ever made, and can be ranked alongside the works of Vroman, Kate Cory, *et al*.

It was a classic interior motif but one that called for an exposure in the failing daylight of about one second at f-8. However, as the place was about to close for the day, there was no time left to run back to the car for a tripod. My only option was to try a hand-held shot with the camera pressed firmly against the door frame. The only problem is that a fixture like a doorway limits one's compositional talents; there is often a better position where a tripod would give a better view. But away from props such as doorways, a long time exposure like this would definitely need a tripod.

Luckily it worked – but only just! Years passed before I tried enlarging this image, believing it not good, i.e. not sharp enough for showing. The result is enhanced by printing it on Ciba (Ilfo) chrome materials which are inherently sharper than conventional colour print papers.

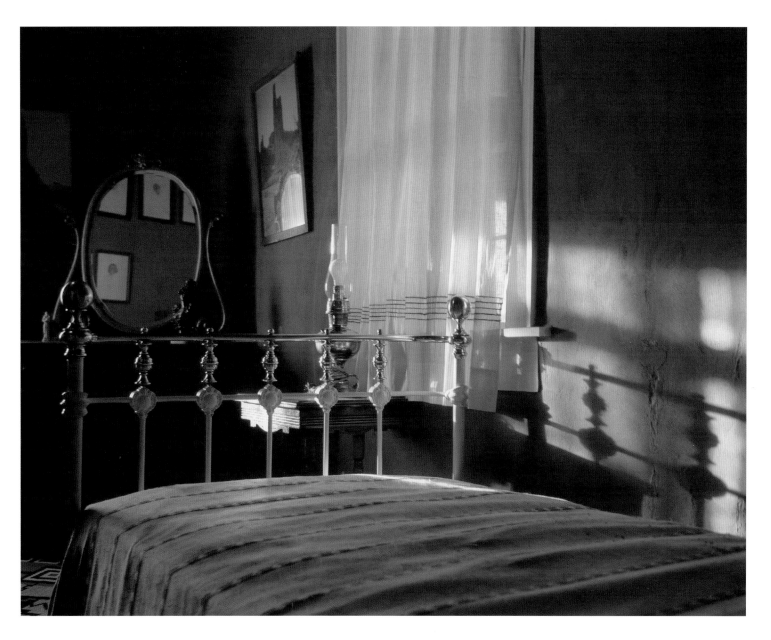

The old trader's bedroom
Ganado, Arizona 1984; Kodak KR 64. Plaubel Makina 67

Etude with sage tea

Strolling into the harbour area of the Greek island of Astypalea, I encountered an English acquaintance forlornly shaking his head as he emerged from the island's only public telephone. He had again failed to contact a recalcitrant lawyer on the island of Rhodes with whom he was negotiating the purchase of a little house in the ancient hilltop village. Purchase of property on any of these Dodecanese islands was a tricky business, but was said to be possible through a Greek national acting as proxy.

This politically sensitive region, so near the Turkish mainland, had seen several skirmishes over Greek oil-drilling operations in the Aegean threatening to destabilize the fragile peace in the mid-Eighties. A Greek photographer had even warned me to be prudent about wandering the Dodecanese armed with several cameras, in case of being thought a spy photographing harbour installations for Turkey! It was meant quite seriously…

To help dispel his gloom over yet another failed phone call he invited me to view the property up in the old *Chora* and enjoy a cup of sage tea, laced with honey. I got no farther than the threshold: a music stand, and an orange-red morning robe hanging on the wall in his living room held me spellbound. To the left of my view was a violin lying in its case on the sofa – another of those hard-to-resist, challenging interiors.

At first it was tempting to place the instrument under the music stand, but then motif honesty prevailed; in any case it would have looked too contrived. The bright daylight filtering through the lace-curtained window set a difficult exposure problem for colour film. Some fill flash would have helped, but in the moment of inspiration I chose to ignore this, knowing it would result in a high contrast image.

A duplicate transparency made via a single-step (1 f-stop) unsharp mask resulted in loss of colour intensity on the morning robe, but made printing a little easier. Enlarged up to 16 x 20 inches, the image is so sharp that a violinist friend said he could read the musical notes well enough to play the étude.

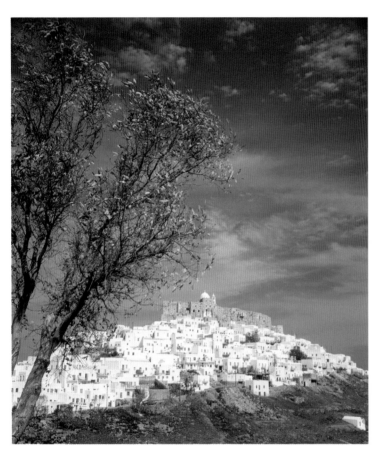

Astypalea Chora

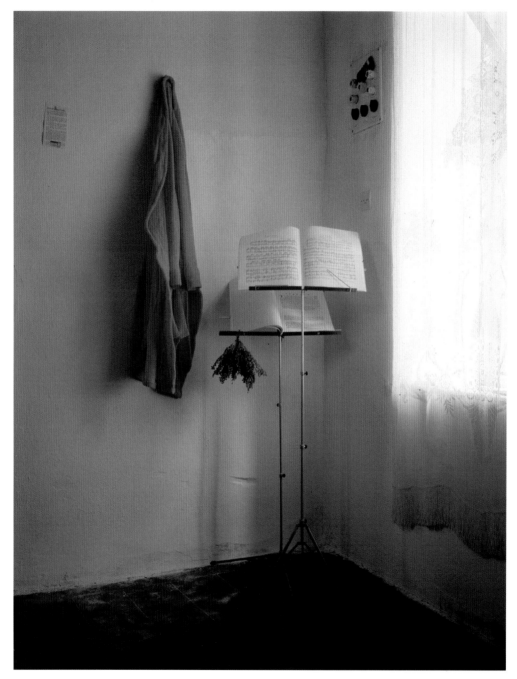

Etude with sage tea

Astypalea, Greece 1987; Fuji RDP. Plaubel Makina 67

More interiors

Whether seen from the street, or inside a room, windows are a universal source of inspiration for photographers and artists. Motifs like flowers and lace curtains, a cat luxuriating, as only cats can, on a windowsill, or the wall patterns that sunshine paints, changing as the hours go by – these are some of my favourites.

As the spring sunlight slanted through the windows of a Paros taverna, a row of butane lamps – hanging on the wall like cliché china ducks – was attractive enough to divert me from a plate of rapidly cooling mousakka, but while an idea is red hot, images come first. The proprietor wondered why anyone would want to take a photo of his lamps when their meal was on the table.

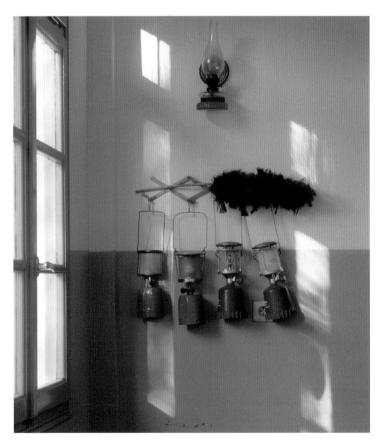

During another pleasant stay on Paros, a bright new shiny bar attracted me several times for an aperitif. It was considerably different from the usual smoky taverna frequented more by the local islanders (always the men folk) than by scantily clad tourists or thrifty backpackers. The spick and span tiled floor reminded me of those classic interior paintings of Jan Vermeer's with their impressive perspective, and inspired me enough to want to make a photographic homage to the great Dutch master. It ended up dedicated to a famous Russian.

I set up the Plaubel 67 as nearly vertical as possible to avoid too many falling lines in the composition, but the angle of view was just not wide enough to include the whole interior as envisaged from just inside the doorway. The result is acceptable but not ideal. A large format camera would have done a better job, using the mechanical adjustments featured on such cameras allowing corrections *on the film plane* to perspective distortions that can and do appear in interior or architectural photography.

The owner, visible in one of the half-length mirrors, watched all these antics with amusement, pointing out that I was lucky to be doing this in the off-season. After all the deliberations, I felt that the scene looked a little too clinical; it needed a touch of colour on the clean white tables – such as oranges. There were some in a bowl on the bar-top, and in setting three of them on the nearest table to look as informal as possible, I knew the title: *For Sergey*. This is the only set-up image in the book, and its title refers to Sergey Prokovief's *opera buffa, L'Amour des Trois Oranges (The Love of Three Oranges,* originally performed in 1921).

For Sergey

Paros, Greece 1987; Fuji RDP. Plaubel Makina 67

Waiting friends

Running through fourteen states, two National Forests, and several National and State Parks, the scenic Appalachian Trail winds along the ridges of ancient uplands for more than two thousand miles, from Maine to Georgia. It is popular with long-distance backpackers who can take several months to complete the walk end to end. Some find it more arduous, or even hazardous, than expected. While trail-side camping spots and shelters are provided in many places, hikers are required to maintain these for the general trail community.

Geologically the Appalachians stem from three vast mountain-building periods beginning almost five hundred million years ago, the last of which created a super continent, Pangaea. Stretching from the southern states Tennessee and Georgia, and as far north as Newfoundland, the Appalachians are the stubby remains of mountains that may have been as majestic as the present Himalayas. The Appalachian flora is incredibly rich, with over one hundred and forty species of trees and some two thousand plants. Folks say that bears can be seen on the trail, though encounters are increasingly rare.

The word *Appalachia* is derived from an Indian tribal name *apalachee*, but for me it has other associations: Aaron Copland's ballet suite *Appalachian Spring*, commissioned by the celebrated choreographer Martha Graham – and springtime walks along sections of the trail in the Great Smoky Mountains. And in the autumn the lush forests abound in colour, to the delight of many photographers using cameras of all formats.

On a farewell trip to the Deep South in '86, I hiked up to Clingman's Dome, highest point in Tennessee, then dropped

On the trail

in to the mountain hut on LaConte, where the polished wood interior and chairs clustered around the stove like waiting friends – surely a welcoming sight on a cold winter's day. Naturally, it beckoned to the lens in my head.

Waiting friends

Tennessee 1986; Fuji RDP. Plaubel Makina 67

DIGRESSIONS

Astypalea chapel

If there ever was such a competitive event as The Curiosity Stakes, Mrs Patricia Todd would win easily, streets ahead of the rest. I mean, show her the door to a church, or a public building anywhere and she immediately tries to open it. We simply *have* to see what's on the other side, even if a sign says clearly 'Closed', '*Chiuso*', '*Fermé*', '*Geschlossen*' or '*Klystos*'.

This was one of those moments. Normally an optimist, I had already wandered past this tiny chapel believing there was no point in looking – it's certain to be closed. But hearing the cry 'Come, look at this', I knew this was wrong; the door was indeed open. My attention was not taken by the interior, but by the white façade against an azure sky and the red wrought-iron gate with a little cloud floating ideally above it. However, by the time I had fished out the Plaubel from the rucksack, the wispy white cloud had almost dispersed. Luckily, I didn't need the tripod which would have delayed things even more.

Curiosity usually gets the better of me too, and on peeking through the door I saw a typical Greek Orthodox interior, sparsely decorated with reliquary, icons and a tiny altar, all in a space about the size of a Japanese family car. With the camera pressed against the door frame, and trying not to block the light from the patio outside, it was enough for a hand-held one-second exposure – OK if you have a steady hand and keep off the ouzo!

This was another of those occasions when I could have used my favourite bean bag. Worth more than its weight in beans, it moulds to any form on top or underneath, supporting the camera as well as any tripod could. I recently described how to make one in *From Seeing to Showing*.*

* Published in the US as *Elements of Black & White Photography.*

I think country folk everywhere are taking a risk by leaving their precious religious artefacts open for all to view. In fact many small and large communities have had to close their church doors to the public because of art thieves and unscrupulous dealers. Perhaps this tiny church has also closed its doors now.

Devotional ikons

Red gate, white chapel

Astypalea, Greece 1987; Fuji RDP. Plaubel Makina 67

Fuzzy harbour

A short distance along the Astypalea coast road, not far from the tiny chapel described earlier, a harbour lay nestled in a tranquil bay. It was so sheltered that the multicoloured boats were barely moving on the sun-dappled water. With puffy little white clouds floating above, the scene looked more like a piece of naive art.

The road was slightly elevated above the coastline, giving a low-angled, bird's-eye view of the harbour and without more ado I snapped the scene with the Plaubel – but a little too quick off the mark, because my improvised dust cap was still covering the lens. This is very easily done with rangefinder cameras, especially on older models.

I had long lost the original Plaubel-Nikkor lens cap, and by chance had found a translucent white plastic lid (from a container of Parmesan cheese!) that fitted over the lens perfectly. Cursing my stupidity, I made a couple more exposures of the same scene, and put the lid/cap in my pocket. Clearly some kind of system was needed to prevent it happening again. The solution was easy. I fitted a length of cord with elastic around the lens – one of those handy devices to prevent the cap from falling off unnoticed, as they so often do. By shortening the cord so that the Plaubel's bellows could not be fully opened, it signalled that the lens cap (a clip-on type from another camera) was still attached.

Like so many others, the film lay in my files for years until one day, while looking for something different to print, I tried this 'fuzzy' impressionist image. The result confirmed my belief that one should never scrap positives (or negatives) that *might* turn out to be useful. Ergo: discard only total disasters.

I made the same mistake again a few years later with another Plaubel 67 – one that still had its original black plastic lens cap. Midway through the foundation-stone laying ceremony for our new village fire-engine house, I ran out of film, typically at the wrong moment. Returning to the fray with a fresh film, I noticed the Mayor looking at me in a curious way. He was clearly wondering what kind of pictures could be made through a capped lens. Absent-mindedly, I had replaced the lens cap while changing films. Yes, all ten exposures were blank, candidates for a book I thought of making many years ago. Contents: a hundred clean white pages entitled *Pictures I never took.*

While sorting through a box marked 'odds & ends from others', I was recently surprised to find a little colour picture of this event, showing myself making this disastrous change of film. Perhaps the anonymous photographer had seen what was about to happen – though I wish he or she had yelled 'lens cap off'!

When I related these wacky tales to the owner of a real photoshop he recalled that, back in the Fifties, a customer had threatened his father with court action. Not one image from an expensive journey through darkest Africa had come out in the gentleman's new Leica rangefinder III F – apparently he didn't know about the lens cap! A sorry story, but classic case of 'when all else fails, read instructions'. And yet how often do any of us do this first?

Fuzzy harbour

Astypalea, Greece 1987; Fuji RDP. Plaubel Makina 67(cropped)

Texan trifles

Taking a weekend break from NASA Shuttle launch preparations at Houston, I headed for the picturesque Atlantic resort of Galveston. It had been badly hit by one of those violent hurricanes that sweep the Texan coastline from time to time; punishing winds that had left a trail of damage far inland. I didn't go for ghoulish reasons, to see how the harbour had suffered, but simply to enjoy sea air – a welcome change from air-conditioned Space Center control rooms.

Somewhere en route, I stopped to photograph a church that appeared to be built in traditional adobe style, though I doubt if this was really the building material used. To get a better view of the church tower, and avoid falling lines in the image, I stepped back into the forecourt of a service station. An orange-red sign 'Cash or Credit Card' caught my eye and instantly added another dimension to this motif, epitomizing a life-style no longer limited to America.

Though *Cash or Credit!* has been exhibited several times, so far only two mounted and framed 16 x 20 inch Cibachrome copies have been sold: one to a urological specialist doctor, the other to my dentist. While I am sure they liked it simply as an attractive picture, cynics might say there must be a Freudian connection.

To be fair, the doctor bought *nineteen* other pictures (many of them illustrating these pages) to decorate his new practice. Hopefully his patients are not too troubled with their aches and pains to appreciate the colours. The dentist's copy hangs in the patient's toilet, where I presume they can meditate on the pain of double extraction: physical and fiscal!

Texas red grass

This is another of those images that belie the banality of their origin. It was seen in the parking lot of a fast-food restaurant while shooting abstract reflections on the chrome-plated mirror on a parked truck. This photographic doodling was cut short on sighting a few blades of grass peeking through a gap in a heavy panelled red and white painted wood fence around the plot.

The faint shadow angled across the painted wood is what initially attracted me – like a sundial, a kind of 'Kilroy was here' marker that probably no one else would see or even interpret thus; a simple snapshot, with little thought of it being any more meaningful. As photographed, the motif is banal but drastically cropped on the top and both sides it made an attractive image and a cover picture on *Photo Art International.*

Turquoise Trail shop

Running north out of Albuquerque, on New Mexico Route 14, there is a triad of small towns made briefly prosperous by the mining of gold and coal – also high quality turquoise, mined and esteemed by Native Americans long before white settlers came in search of wealth. This string of pioneering gems is on the Turquoise Trail, which really begins at Golden – one of the first places west of the Mississippi where gold was discovered in 1826. What followed at Golden is typical boom town history: it grew, it prospered and faded. It became a ghost town in the true sense of this overused label – and that's how it looked as I walked down a practically deserted highway in January 1991.

Cash or Credit!

Texas 1983; Agfa R 100 S. Plaubel Makina 67

Texas red grass

Texas 1983; Agfa R 100 S. Plaubel Makina 67

A short distance away, the church of San Francisco stood dominating the landscape, its brown adobe form clearly outlined against the snowy hills and the winter silence seemed to emphasize the lost, lonely feeling.

On the edge of town there was a bric-a-brac and souvenir shop complete with a Coca-Cola vending machine, its faded red paint contrasting against the snow looking like something out of Hollywood, a classic time capsule. Knowing instinctively it was one of those one-in-a-million images I quickly forgot the cold and made several exposures on a black and white film, then balanced the Plaubel on top of the Hasselblad's viewfinder for an almost identical Fujichrome version. The monochrome image is featured in my 'How to' book, *From Seeing to Showing.**

There is a golden rule (pardon the pun) that says one should never return to a place of happy memories (or good images). I *did* return to Golden in 1995 and found this old saw to be true. Apart from noting that the adobe walls of the church were not so photogenic under a coat of white paint, the old Ice Cold Cola machine had gone from outside the souvenir shop, perhaps sold to a collector of Americana.

The shop itself was not looking so good either and even the Dodge car was nowhere to be seen. Normally these old wrecks just fade away into the ground. The last time I saw the place, in the autumn of '96, it looked in ruins and almost invisible behind a natural barrier of bushes and trees.

*Published in the US as *Elements of Black & White Photography.*

Unloved 1

Golden, New Mexico

Turquoise Trail shop
New Mexico 1991; Fuji RDP. Plaubel Makina 67

All you need is love

The former republic of Czechoslovakia was high on my list of countries to visit – if, or when, the Iron Curtain fell in communist-ruled Europe. Barely six months after the 1989 Velvet Revolution, a grand tour through the lesser-known parts of this culturally rich country only served to whet the appetite for more. It was a journey that began by following the river Moldau (Vltava), like Bedrich Smetana's tone poem *Má Vlast*, from the source to its confluence with the Elbe – a leisurely trip that also took in some of the High Tatras on the Polish border. Some of the more remote hinterland villages reminded me of life in the sixteenth century as depicted in paintings by the Flemish master Pieter Brueghel.

A couple of years passed before a chance came to renew the acquaintance, through a long-weekend package tour organized by German Railways; four days devoted to the music that Wolfgang Amadeus Mozart wrote in Prague – and to visiting sights familiar to me through Josef Sudek's work. His large-format panorama photographs of that elegant pre-war city earned him the name 'Poet of Prague'. The tour itinerary included a conducted walk through the old town, past famous buildings such as Kafka's house, the street of goldsmiths, and several places connected with Mozart's greatest works.

Along the route, we passed a high wall decorated with graffiti featuring a poignant image of John Lennon. *All you need is love* had turned the wall into a powerful memorial – a place where in the closing years of communism the youth of Prague, and older generations, not only mourned his passing but also registered a highly visual protest.

In the fading November sunlight, a tree's shadow arching across the wall seemed to epitomize the ephemeral nature of all regimes, oppressive or benign, and accentuated the significance of this spot. There were just a few moments to contemplate these ideas and to make this colourful image before the tour group hurried on to the next point of interest.

To the right of this shadow, sharing space with a myriad of graffiti on a panorama of plaster, was another musical icon: the Rolling Stones, the first internationally famous pop group to visit the new Czechoslovakia. This was said to be at the special request of a leading fan: President Václav Havel – a founder member of *Charter 77*, a dissident group that helped trigger the collapse of the communist system. It seems that contraband music cassettes of the Stones had sustained him during a four-year-long confinement as a political prisoner and his campaigning as a human rights activist.

All you need is love...

Prague, CSFR 1992; Fuji RDP. Plaubel Makina 67

Changing times

There was a time when the frontiers between France, Spain and Portugal were sinister places patrolled by heavily armed men of the Guardia Civil in their shiny black patent-leather, three-cornered hats. Once feared, even hated, for their perhaps only feigned hostility, nobody portrayed them better than W. Eugene Smith in a photographic study of old Spanish village life. His graphic shot of three Civil Guard soldiers is still, for me at least, the most evocative image to emerge from the totalitarian Franco era.

The Shengen Treaty (1990) banished these international frontiers, making it easy to traverse several European nations without having to show a passport or identity card. Nevertheless, it gives one a strange feeling to pass through these old ghostly border posts still redolent of xenophobic distrust. Some have vanished entirely while others are sad reminders of the national pride lavished on them, like the beautifully decorated Portuguese transit station at Vilar Formoso.

Mural ceramics like these are found in many parts of the Iberian peninsular where the influence of Arabian culture is still very evident. The ancient art of tile-making (*Azuejos*) came originally out of Persia, spreading via southern Spain to Portugal, and is seen in its beautiful blue glazed forms in public parks, buildings, churches and monasteries, often depicting local scenes or national monuments.

With the old frontiers gone one can now cross bridges with a freedom that was once only dreamed of by architects. Even in the late Seventies Portuguese border guards stopped me on a rough track that led nowhere; now, thanks to European Community funding, that same track crosses into Spain on shiny new tarmac.

National pride portrayed in ceramics

Vanishing frontier

Serra da Estrella, Portugal 1992; Fuji RDP-2. Plaubel Makina 67

CHAPTER THREE
Landscapes

W ell, *really* – anyone can take a landscape...' I overheard someone comment at a fashionable reception to open an exhibition of photography. Wrong, completely wrong! With the possible exception of portrait and nude studies, the traditional landscape is perhaps one of the most difficult subjects to tackle in straight or representational photography.

Finding attractive scenery is obviously a prerequisite – though not always so easy as it would seem. Since the spread of communications towers and high voltage transmission lines the ideal landscape is practically a thing of the past. The perfect seascape is even more elusive. In both cases, nature plays a major role: her seasonal moods, the weather and, of course, the land (or sea) itself. Feelings too are a significant part of one's approach to a subject, be it a rock, a mountain, or a field of flowers. Without commitment the resulting image will be sterile, photography for its own sake.

Naturally some imposing storm clouds will help to make a memorable picture. The sense of movement too, and the physical world of sound: a field of waving grass or a roaring surf, all elements that can be easily recreated in the mind's eye – and ears. And yet, despite these design criteria, many of my pictures are intuitive compositions triggered by some emotional response to the scenery or subject.

Colour complicates all these factors and can easily turn a picture into an unworthy piece of kitsch. It is a tricky course to run, but I always rise to the challenge and enjoy the chance to produce something a little different from the norm.

Where possible, I try to find something of interest in the foreground or near distance that lends depth to a photograph. Artists have long used this technique, known as 'staffage', in their landscapes, knowingly adding a few animals or a group of peasants in the foreground to create a three-dimensional impression, guiding a viewer's eye *into* the scene.

Traditional art offers valuable lessons in composition, and the use of colours, light and shade. One can learn so much from a study of works by masters like Jacob Ruisdael, John Constable or John Sell Cotman, to name some of my favourite landscape artists. In photo workshops, I usually urge participants to visit the local galleries or museums – especially those exhibiting classic landscapes and portraits – to see how the great painters used colours, and exploited their juxtaposition to great effect.

Alpine staffage

Flower border

Portugal 2002; Fuji RDP-3. Plaubel Makina 67

This picture is an example of the dangers affecting nice landscapes. They could be likened to a hair-raising mountain-ridge walk teetering, in this case – as already indicated – between art on one side and kitsch on the other. Accordingly, I left this image out of my final selection, but too many people said they liked it...

LIKE A PAINTING

'It looks like a painting!' This remark is invariably made when people see some of my pictures for the first time. Naturally I accept this as a compliment, but if I were a real artist applying paint to canvas it might be disappointing to hear someone say, 'Is that a photograph...?'

On the other hand, it is known that artists in the recent past have used photography as a tool, principally to document a scene for later work in the *atelier*. There is increasing proof that artists even before the Renaissance used a *camera lucida*, the evidence for this being the quantum jump in the use of perspective.

The Greek philosopher Aristotle described the function of a *camera obscura* as early as 350 BC, while it was the Arabian, Ibn al Haitham, who gave it its Latin name meaning 'dark chamber'. Historically, it was rediscovered twice: first in the fourteenth century by Peter of Alexandria and again in the sixteenth century, when Giovanni Battista Porta described it in detail. In the sixteenth century, Leonardo da Vinci published a paper on the *camera obscura* as an aid to better draughtsmanship. Fellow artists began using it and set the stage for developments that centuries later became photography.

The paucity of British landscapes in my portfolio is because I have lived abroad for over thirty years. My work took me to several countries in Europe, Greenland and America, opening many chances for photography. It should be no surprise therefore that it contains no landscapes from my old homeland.

Nevada eventide

Heading reluctantly away from Yosemite California, going via the Sweetwater Mountains into Nevada, I was fascinated by a panorama of brilliant white clouds floating like dirigibles in the late afternoon sky. These cloud formations are often seen over mountain forelands, particularly in Bavaria where they are a result of a warm wind blowing over the northern Alps. This common meteorological event is known as a *Föhn* (German for hair drier). It also causes headaches, a rash of traffic accidents in Munich and has even been blamed for suicides. Some people are so sensitive to this phenomenon that they have complained about my Alpine landscapes depicting such clouds.

...like dirigibles

Nevada eventide

Nevada 1981; Kodak KR 64. Hasselblad 2000 FC

The evening landscape reminded me more and more of Jean-François Millet's quiet pastoral scenes. His work made him an important member of the mid-nineteenth century Barbizan school of landscape painters. Among the too many images I made on a Grand Tour of America back in 1981, traversing twenty-two states, this 6 x 4 cm transparency has all the qualities I would like to convert to a painting – thereby closing the loop where I started at art school sixty years ago…

One of the late-eighteenth-century artists I admire most is J M W Turner, particularly for his use of colour in a way that foreshadowed the Impressionist movement almost a century later. The image opposite was one of several dozen made while on a packet ship heading into the incredible Arctic midnight sun, as the skipper skilfully dodged icebergs and floes between the west coast of Greenland and Disco Island. It is an image that always reminds me of Turner's astonishing works, such as the *Fighting Temeraire*, ablaze with colours that must have shocked the art establishment of the day.

Midnight sun
West Greenland 1976; Kodak KR 64. Canon F1

Eighty-five per cent of Greenland is still covered by the world's second largest ice sheet, a living reminder of how the landscape looked near my home in the Alpine foreland as it recovered from nearly a *hundred thousand years* of the Würm Ice Age. As global warming takes a hold, the images I made near the ice sheet on east Greenland are already historical documents. They show how it was before the 'Great Melt' started. I doubt if many politicians know (do they care?) just how high the sea levels rose during the last great interglacial period that reigned for some hundred and thirty thousand years *before* the first Würm cold phase – but then our 'dumb' ancestors would have simply moved to a new cave higher up the cliffs, or drowned...

85

A good shepherd

More than any other in my collection, this picture illustrates the level of awareness needed for seeing those rather special motifs. I was heading into a fine sunset in the High Sierras of southern Spain, in the province of Almeria, when this image simply came out of nowhere.

The route was far from the beaten track, not even marked on a good map. Nevertheless, after being almost lost among some really high snow-capped mountains, it was good to have found a way out through a range of soft, rounded hills, mesas and valleys. Perhaps it was the beauty and utter tranquillity of this empty landscape that set my image reception sensors to high sensitivity, prompting me to stop and shoot the ever-changing scenery several times.

In the High Sierras

Rounding a bend on the dusty track, I saw a shepherd with his flock and dog coming towards me on an adjoining trail. It was a classic backlit sheep motif, the kind that Alfred Stieglitz said he had seen one too many of! Braking to a slithering stop, I leapt out while resetting the Plaubel lens a stop wider open, clicked the shutter, and – shouting 'gracias' – was on my way before you could say 'Don Quixote'.

It was another of those lucky one-in-a-million shots that resulted in this classic landscape, though in fact it is a problem image. For a satisfactory print on glossy Ilfochrome it needs a one f-stop mask to cope with an uncomfortable range of contrast.

Under less hectic conditions a well directed dose of fill-flash would have illuminated the shepherd and his dog better, though at that range it would have needed a very powerful flash unit. Fill-in illumination is easily overdone, however – often noticeably. A graduated neutral density filter might also have helped to reduce the overexposure in the sunlit side of the sky. Such tricks are easier written about than done, and are usually not practical in such split-second actions as these. Capturing the exhilarating moment is far more important.

A Christmas card of this image, made the following year, never sold well until a recent showing of my monochrome American Southwest images. Several gallery visitors thought that *A good shepherd* had been photographed somewhere in Arizona, though the shepherds you would find there, tending their flocks in that otherwise similar country, are Navajo nationals. But what the animals find to eat among the desert sand dunes is a puzzle.

A good shepherd

Almeria, Spain 1987; Fuji RDP. Plaubel Makina 67

White Sands

Deserts are some of the most inhospitable regions of our natural world; they have presented a special challenge ever since the first keepers of the light took their caravans of bulky studio cameras and wet-plate paraphernalia into the wilderness. Of all the American desert landscapes there is perhaps none more daunting to photographers than New Mexico's White Sands. This popular National Monument is part of an extensive wilderness area that extends some sixty miles northwards, from Alamogordo to the Valley of Fires lava flows near Carrizozo and the Malpais beyond. The invading Spanish Conquistadors named this region 'bad country' or *el Malpais.*

Much of this unique landscape is used as a range for rocket and guided missile tests, placing large areas of the desert out-of-bounds to the public. And not far to the east, a mere thirty miles from Carrizozo, the first atom bomb was exploded at the desert Trinity site on 16 July 1945.

Mineral salts (borax, gypsum, etc.) lying deep under the San Andres and Sacramento Mountains are washed out by seasonal rains into the Tularosa Basin's Lake Lucero, which then evaporates to leave its muddy bed encrusted with gypsum crystals. Summer winds weather the crystals into fine particles, building the most beautiful white dunes, a process that has been going on for geological ages – and will surely continue for many thousands of millennia to come.

The highly reflective gypsum surface of White Sands – clearly visible from an orbiting spacecraft – presents a formidable exposure problem for films and people alike, especially in the bright daylight and heat of midsummer. But in the winter months the sands become a wonderland of sugar-candy forms as the sun rises late and rosily over the south-eastern edge of the dunes.

I went there in January, when the desert can be very cold. Indeed, the winter of '91 – one of New Mexico's coldest – was so chilly that the Hasselblad and its user were frozen stiff. To be fair, I should have used my parka to protect the camera before exposing it to the arctic-like cold. Luckily the results from a back-up 6 x 7 cm transparency are impressive either as an Ilfochrome print, or a black and white print made from a duplicate negative on Polaroid 55P/N film.

El Malpais

White Sands dawn

White Sands, New Mexico 1991; Fuji RDP. Plaubel Makina 67

UNDER WESTERN SKIES

A two-billion-year hike

Arizona's Grand Canyon of the Colorado River is without doubt the world's greatest natural wonder. All the year round it attracts huge numbers of visitors, some gazing for ages into the dizzying depths, trying to absorb its impact. Conversely, I've seen others take a quick peep over the rim-side barrier, then dash off to the next signposted 'Kodak Photo Stop'. This mighty canyon deserves more respect than that.

Long-distance walker Colin Fletcher was so enthralled with his first glimpse of the immense chasm, that he immediately decided to trek the length of it, *alone* – a journey that took two months, following a full year of research and planning. Fletcher's odyssey into unknown terrain is described in his book *The Man Who Walked Through Time*, an inspirational tale about one man's confrontation with his infinitesimal role in the universe.

I often recall my outing on a scorching June day in '81 and the sheer bliss of drinking camel-like quantities from a cool spring at Indian Gardens, on the Bright Angel trail, on the way up to the canyon rim still a few hours away. By contrast, the Kaibab is an easy trail in almost any season, but as there are no trailside water sources hikers are advised to backpack a few litres of water.

The last unforgettable stretch of that thirteen-hour jaunt was accompanied by a thunderstorm sounding a strident coda; there's no shelter from the elements within those fearsome walls. But if such an adventurous trip is too arduous to consider, then take a traditional mule ride – and a cushion to sit on afterwards!

Either way, in summer or winter, to go all the way down into this great canyon is like making an astounding journey through *two billion* years of the planet's natural history, nearly half the age of the solar system. It is a humbling trek that all steadfast Creationists should make at least once in their lives. Of course, if you believe in Irish Archbishop Ussher's theory that the world was built in 4004 BC, at nine o'clock in the morning, then I've wasted this space!

The inner gorge, still 1200 feet to go - and it's a long way back!

Summer storm in Grand Canyon

(spot the hiker!)

Grand Canyon 1981; Kodak KR 64. Hasselblad 2000 FC

Alfresco in Utah

Despite a significant increase in pollution over the last forty years from the Four Corners coal-burning power generators, the view was magnificent along Comb Ridge; one could see at least eighty miles as it curved away into the distance in the brilliant early morning air.

Four Corners is that singular spot on the map where four American states (Arizona, Colorado, New Mexico and Utah) meet. But except for a 'point of interest' marker and the superb red rock landscape, there is not much else to see at this point of cartographical exactitude. Nevertheless, it is a good starting point for many of the southwest's scenic wonders.

Along Comb Ridge

Natural barriers like Comb Ridge, a steeply angled and eroded sandstone anticline, must have been daunting sights to Mormon settlers on their epic trek to find and establish a haven free from persecution, to reach that great lake in the west. Travelling by covered wagon and on horseback, and learning to survive in the wild and often inhospitable West, was tough enough let alone having to negotiate geological features like these.

During the winter of 1879–80, they built a trail between Escalante and Four Corners. At one point in their strivings they even had to widen a cleft in a sheer canyon wall, manhandling their wagons through the resulting gap in the cliffs. This characteristic story of pioneering determination earned this trailblazing episode the name 'The Hole in the Rock Expedition'.

Perched high up on Comb Ridge's lee side, with Gene Foushee, geologist and guide from Bluff, Utah, I breakfasted on 'cowboy potatoes', eggs and bacon and coffee prepared over an open fire – an inspiring start to a wilderness trip and photo-safari in summer 1981. But as a fiery sun rose above a distant mesa it was time to douse the fire, get down to the valley, and start trekking. While Gene went ahead, I was waylaid by a solitary tuft of grass clinging to the sandstone ledge – and in my enthusiasm to photograph it, nearly forgot the long drop below!

Comb Ridge grass

Comb Ridge, Utah 1982; Kodak 6017. Hasselblad 500 CM

The hunter and the hunted

In the silence of Mystery Valley, where an Anasazi family had lived in a tiny cave shelter in peace and seclusion perhaps a thousand years ago, converging tracks in the dunes told of the eternal fight for survival, a drama played out perhaps only moments earlier.

Camping for the night on a stony plateau, with a view across to the Pancakes and distant Monument Valley, the embers of another wonderful sunset let that sleepy, contented feeling take over – except that the Great Cosmic Show above was too good to miss. The night was so still that even the slow passage of satellites seemed to intensify the desert silence.

A dazzlingly bright Milky Way rotated slowly over us, as occasional meteors ended their solitary journey through the galaxy in a fiery flash, leaving an afterglow in the deep indigo sky. It seemed such a brief, almost meaningless climax after four billion years in orbit since the formation of the solar system.

Waking in the cool of dawn, a set of tiny paw prints in the sand behind our heads caught my attention. A nocturnal visitor, a prairie dog or perhaps some other desert mammal, had been checking our slumbering forms. Better than a rattlesnake, however, who might have tried sharing the warmth of my sleeping bag – a not unknown surprise, I've heard tell. Moreover, never forget to turn your boots upside down in the morning to shake out more than a few grains of sand; it seems scorpions like the smell of sweaty socks!

Yosemite

If asked to choose between the top three National Parks of America, I would probably pick California's Yosemite for its sheer grandeur. Possibly the world's best-known glacier-carved canyon, it has been called 'The Incomparable Valley'. Eons ago a gigantic river of ice flowed through the pre-existing valley, grinding past the granite mountains to form familiar features such as Half Dome and El Capitan.

Yellowstone in Wyoming and Arizona's Grand Canyon, have their plus points of course, but Yosemite has more of everything: glaciated peaks, high sierra trails, a rich flora and fauna – and, like many of America's park lands, far too many tourists. Yosemite's founding father, John Muir, would be horrified to see what he, in effect, began. America's greatest landscape photographer Ansel Adams lived and worked in Yosemite for forty years. A passionate defender of US National Parks – indeed any place of natural beauty – he too must have wondered what the future would bring to this wonderland.

Mirror Lake, Yosemite

Yosemite, California 1983; Agfa R 100 S. Plaubel Makina 67

For years, conservationists have been warning that these wilderness areas are being 'loved to death' through the excesses of tourism, and that this environmental damage must cease, accusing the National Park system of having no viable plan. But away from the hotel accommodations, log cabins and car parks, one sees little evidence of this overpopulation.

There were few people around in December '83 when I took an afternoon stroll along the icy trail beside Tenaya Creek – nobody to see the foxes and other wildlife, or to enjoy the wooded landscape, crisp air, and winter sunshine. The trail looped back toward Yosemite village, along the creek's south side, where the dark tranquil waters of Mirror Lake were reflecting a perfect image of the sunlit mountains.

The range of light between the granite slopes and a near freezing lake in deep shadow, was too great for normal colour slide film – a black and white film would have coped better with such extreme contrast. I compromised as usual with an average reading of the lake's reflections, hoping (clearly in vain) to correct the inevitable over-exposure in a print.

Dwarfed beneath Half Dome, there was a real peace and stillness mirrored in the seemingly immutable nature – sentiments to belie the urgent worries of well-meaning environmentalists. I was humbled not only by the majesty of my surroundings, but also with the knowledge that Adams had done some of his finest work in this beautiful place. And yet, Henri Cartier-Bresson couldn't understand how anyone (Adams) could devote his time to photographing a landscape when 'the world was maybe going to pieces.'

Canyon de Chelly

'Our village was healthy and there was no place in the country possessing such advantages, nor hunting grounds better than those we had in our possession. If a prophet had come to our village in those days and told us what things were to take place, none of our people would have believed him.'
Chief Black Hawk (Sauk) c.1832

If there had ever been a paradise on Earth, it must surely have been in Canyon de Chelly – until the new Americans began a pitiless crusade against the Navajo, or Diné, as they call themselves. Though it was known, and even marked on early eighteenth-century Spanish maps, Canyon de Chelly was not fully explored until 1848.

In 1862 Kit Carson, then a colonel in the US army, led a mixed force of other Indians and Hispanics in a vicious purging of the Navajo folk from their native homelands. They were brutally hounded out of their canyon stronghold, with many survivors fleeing to a nearby peak, Fortress Rock – only surrendering when near to starvation; some jumped off the cliffs rather than submit to the white man's dominion. Carson's marauding troops burnt the Navajo's hogans, destroying their carefully tilled fields and much-revered orchards of peach trees.

After a forced march of four hundred miles – the 'Long Walk of 1864' – in which many died on the way, over eight thousand Navajo and Mescalero Apaches were corralled at Bosque Redondo (Fort Sumner) in central New Mexico. Thousands died of disease or famine as a result of this terrible exodus.

White House Ruins

Canyon de Chelly 1982; Kodak KR 64. Hasselblad 500 CM

The ensuing, heated outcry ultimately led to Congressional commissions in Washington where belated efforts were made to improve the Navajo's lot. In the meantime, the Apache managed to slip away back to their ancestral homes in the White and Sacramento mountains.

Four years after the affair began, the plan was acknowledged to have been a misbegotten idea and the main instigator, General James H. Carleton, was relieved of his post. By convincing General Sherman that they would really be better off in their old homelands, the Navajo negotiated a treaty with the US government acknowledging sovereignty over their old lands.

The Navajo were assisted back to the Canyon de Chelly and surrounding areas on a huge reservation straddling the borders of Arizona, New Mexico and Utah. But things were not quite the same, nor ever would be. In an appallingly ill-judged way, it resulted in the making of the largest Native American tribe in the United States.

When pioneer photographer Timothy O'Sullivan visited Canyon de Chelly in 1873, he must surely have seen evidence of the devastation wreaked by Carson's troops, though there appear to be no reports in any contemporary literature. His still definitive black and white picture is entitled *Ancient Ruins in the Canyon de Chelly, New Mexico*.

O'Sullivan was not being inaccurate; the Territory of New Mexico at that time included Arizona, land that was acquired from Mexico in 1853 through the legendary Gadsden Purchase. New Mexico gained full statehood in 1912 when Arizona also became the 48th separate State to join the Union.

O'Sullivan's remarkable image inspired legions of artists to make a similar picture, most notably Ansel Adams' beautiful rendition called *White House Ruins* made as part of the Mural Project for the US Department of the Interior in 1941–42, and described in *Examples: The Making of 40 Photographs*. He made several trips to photograph this outstanding site, including one back in 1937 with Georgia O'Keeffe – an event he recorded with a Contax 35 mm camera and illustrated with a contact sheet in *Letters and Images 1916–1984* (pp 98, 99).

When I hiked down an easy trail into the canyon's southern end in 1982, to pay similar homage to these remarkable ruins, the rumbling of an approaching summer storm seemed to enhance a sense of melancholy and sadness pervading the atmosphere. It was naturally tempting to look for the spot where O'Sullivan and Adams had made their masterpieces of the White House ruins under the 'desert varnish' streaked canyon walls

The pale green fluttering leaves of cottonwood trees simply cried out for a colour interpretation, an idea, however, that might have raised an eyebrow or two among my distinguished predecessors. The motif seemed to radiate peace and tranquillity, a feeling helped by the colours of rocks and leaves – quite the opposite of O'Sullivan's strident monochrome tones.

The cottonwoods were planted by the authorities for site and soil stabilization purposes back in 1942, the same year as Adams's first version of *White House Ruins*. Unfortunately the indigenous plants are suffering now through the introduction of exotic species with their voracious demands on the seasonally intermittent groundwater.

Winter seas
Big Sur, California 1983; Agfa R 100 S. Pentax 67

Point Lobos

There is a spot on the Californian coast south of Monterey where one of the greatest photographers of the twentieth century, Edward Weston, found new ways of poetic expression among the seaweed and colourful ocean-tumbled granite: Point Lobos. His nude studies are just as style-setting and fresh as when he also focused his large-format camera on ancient juniper trees atop that scenic headland – the famous Five Mile Drive. This is still the main attraction for visitors, some of whom will have never seen or heard of Weston's masterworks. Many come simply to enjoy the roaring surf at Big Sur, or watch the whales dancing.

I went in tourist-free winter and watched from the cliffs above a quiet inlet as sea otters, floating on their backs, used pebbles and their bellies as anvils to crack open shell-fish – great free and natural entertainment. The rocks were draped like sculptures with sea green kelp, and hollows were mortars for smaller pebbles eroded from the mother rock, to be ground into sand in the never ending geological cycle of order to chaos, back to order. It is a place where one should tread quietly…

For E.W.

Point Lobos 1983; Agfa R 100S. Hasselblad 500 CM

GEO-PICS

Rocks and mud

Utah figures high on the itinerary of tourists to the American west, especially Zion National Park. Its spectacular scenery ranges from deep gorges and breathtakingly high mountains, to barren rock-strewn wildernesses. Whether in a scorching summer or on icy winter days, the land is saturated with colours '...such as no pigment can portray', wrote geologist C. F. Dutton perceptively in 1880. 'They are deep, rich and variegated; and so luminous...that the light seems to shine out of the rock, rather than be reflected from it.'

These photogenic formations were sculpted from primeval rocks formed of sediments laid down in a Sahara-like region over one hundred and sixty million years ago. The ancient desert sands were wind-drifted into huge dunes, overlapping each other in strata of varying thickness and direction, a natural process that is still happening today. Over an immense span of geologic time, these wandering dunes consolidated into rough sandstones and now form the ruddy-coloured, cross-bedded strata exposed in so many interesting places on the Colorado Plateau – most notably in Utah's famous red rock country. And in one of Zion's many side canyons I found a gully full of damp, rippled mud – an image such as one could only dream of finding.

Running excitedly down to the stream's edge, Hasselblad to the fore, I nearly fell flat on my face into the pristine mud as I skidded to a stop, comic cartoon fashion! Although the sloping soil surface had *looked* dry, beneath it lay some very slick sludge; a messy disaster awaiting the unwary. Almost all gallery visitors who see this picture ask the same question: 'Is that chocolate?' *Geofudge* seemed the natural title.

Ship Rock

Viewed from a spacecraft, Ship Rock must look like a gigantic black spider minus several legs, limbs formed by basaltic lava that flowed into vertical cracks in the overlying sedimentary rocks. The lava solidified into walls (dikes in geo-speak) barely a yard or two thick in places – ramparts that radiate for several miles from this famous landmark.

Its inky black form is visible from a great distance across the high plateau country. There are over a dozen such spiky peaks south-east of Four Corners, rocky remains of a large volcanic field. The best view of these is along Route 666, a magical, feared number of the devil. So take care as you drive; there is a lot of superstition about this road, of ghouls that make people crazy or cause horrible road accidents.

...a dozen or so dead volcanoes in the area

Geofudge

Zion National Park 1982; Agfa R 100 S. Hasselblad 500 CM

It is hard to imagine the size of Ship Rock at the height of its activity some fifteen to twenty million years ago, but it probably stood as high as Mount St Helens before its cataclysmic explosion in 1980. And like its Washington State descendant, Ship Rock had ejected unimaginable quantities of lava from deep beneath the crust, bursting through more than two thousand feet of surface rocks and injecting lava into joints and cracks in every direction in the yielding strata.

Wind, ice and rainstorms over many millions of years gradually eroded the ancient plateau as melt waters and flash floods washed the debris down the San Juan and Colorado rivers that in turn empty into the Gulf of Mexico. Eventually the solidified core was exposed to the elements; the old volcanic stump began to decay further into dust.

Towering still some fourteen hundred feet above the surrounding land – and over seven thousand feet above sea level – Ship Rock does indeed look like an approaching ocean liner. While it is impressive enough for anyone even vaguely interested in geology, Ship Rock (in common with several mountains of the Four Corners region) has a far deeper spiritual significance for American Indians. The Navajo Council considers it an offence to climb this extremely dangerous peak, and have banned it.

To the Indian it is known as Tse' Bit' a'i, airy home of the Winged Monster of the Navajo. When one of the Hero Twins killed the evil Monster and transformed its fledglings into the Eagle and the Owl, he found himself stuck up there, alone on that sinister rock. Monster Slayer had to bargain with Spider Grandmother to help him down. An early recorded case of vertigo, perhaps?

I first saw Ship Rock in '81 from the Interstate Highway 40, near Farmington, but was too far away to get a really good shot. Likewise a year later, under a featureless blue sky, the results were again uninteresting. A further ten years passed (geologically infinitesimal), before I tried a route to Red Rock on the Navajo Reservation – an unmade road that cuts through a natural break in the towering lava wall. It was then but a short distance through the stickiest red mud imaginable, under a light covering of snow, for a good perspective view of the dike and distant peak.

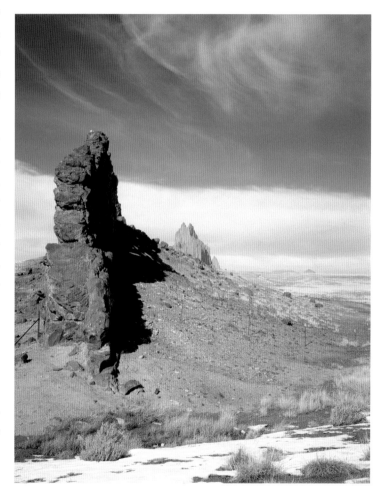

Basaltic wall, Ship Rock

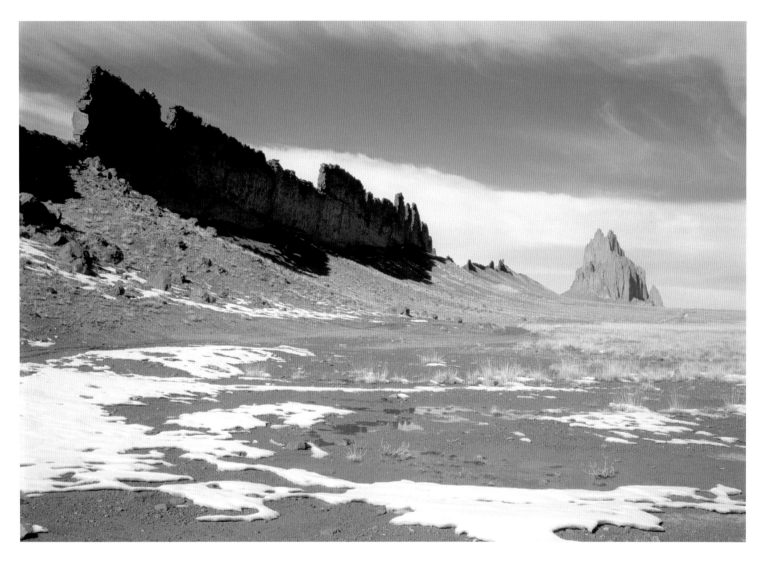

Ship Rock

Ship Rock 1991; Fuji RDP. Plaubel Makina 67

Meteor Crater

Also called Barringer Crater (named for a mining engineer's meteor impact theory), Meteor Crater was formed about twenty-two million years ago when a massive chunk of nickel-iron slammed into the earth with a force greater than any multi-megaton bomb in Man's present arsenal. Geologists estimated that over three hundred million tons of rock were instantly blown out or upended to form the almost one mile-wide crater.

Fortunately cosmic collisions of this kind are fairly rare; the last known large meteor (or asteroid?) fell in a remote forested area of Siberia – the 1908 Tunguska event. Some experts have postulated that it could have weighed up to a million tons, exploding with the energy of ten megatons. Had it impacted just one hour later in its billion year long galactic tour, the rotating Earth would have placed St. Petersburg into the impact zone!

One of the world's largest yet least known meteor craters lies in the German state of Bavaria: the Nördlinger Ries. About eighteen miles in diameter, the crater was initially more than a mile deep. It became a lake that gradually silted up, turning into a verdant landscape where some fifteen million years later the medieval town of Nördlingen was settled – its historic walls are still encircling the half-timbered buildings.

A team from Nuremberg University concluded that this celestial traveller had completely vaporized on impact, and was either an ice comet or a stony meteor about one mile in diameter, or perhaps a lump of iron some five hundred yards across. Whatever it was, the hole left in what became an attractive landscape is one of the largest impact craters still visible on Earth's surface.

The Nuremberg study showed that the resulting explosion was about two hundred and fifty times the force of the atomic bomb that destroyed Hiroshima, Japan. Experiments indicated that temperatures exceeding *twenty thousand* degrees Celsius and pressures of over *fifteen million* atmospheres were attained in just a few fractions of a second! The cataclysmic impact would have thrown vast clouds of dust and vaporized rock high into the atmosphere, resulting in a huge drop in global temperatures.

Black obsidian-like tektites, thought to stem from the Ries event, have been found several hundred kilometres distant on the eastern borders of Romania. Once believed to be solely of extraterrestrial origin, tektites are now accepted as fragments derived typically from meteor impacts. My collection includes tektites found in Java that show traces of streamlining caused by their high velocity ejection and re-entry while still molten.

With these astounding facts in mind, I started out along the nearly three-mile circumference of the crater rim, keeping a wary eye open for lazing rattlesnakes. The sizzling midsummer sun in an azure sky made it almost too hot to admire or photograph the view that stretched way into distant Arizona backcountry. Even the shattered rocks seemed to be ablaze with the fierce sunlight as I focused on the blackened remains of a juniper bush.

Regretfully, I didn't complete that walk but hoped to try again some time. Fifteen years later I found it is now only possible to go about three hundred yards, with a ranger, on a twice-daily trip. A site guard said that a visitor had attempted the Rim Trail wearing inappropriate shoes, stumbled and hurt herself – then sued the management for damages. Now, of course, nobody can walk along the crater rim unattended…

Survivor

Meteor Crater 1981; Kodak KR 64. Hasselblad 2000 FC

Desert illusions

The route going westwards from Las Vegas (Nevada), climbs slowly through splendid Red Rock country, with distant panoramas of snow-capped peaks, before descending to a place we know today as Death Valley, a land the Indians called Tomesha or 'ground afire'.

As the Ice Age ended around twelve thousand years ago, glacier melt waters began to fill the valley, forming a lake that was eventually some one hundred and fifty miles long, and about six hundred feet deep. The present floor of Death Valley near Badwater – a classic *playa* – is two hundred and eighty feet below sea level, the lowest spot in the New World. Rising to over eleven thousand feet at Telescope Peak, the Panamint Mountains on the valley's western flank seem to emphasize the vastness of the place; to the east, the Funeral and Black Mountains complete this desolate enclosure – indeed, a rift valley like its famous namesake in Africa.

In summer, the valley air temperature can rise to a murderous fifty degrees Celsius, an oven-like heat that took my breath away on stepping out of an air-conditioned car at the aptly named Furnace Creek. I clicked off a few Hasselblad frames on a colour film – worthless images thrown out long ago, proving the importance perhaps of actually *enjoying* one's photography!

The valley was a backdrop to some extraordinary stories arising out of the discovery in 1848 of high purity gold in California. It triggered a feverish rush to stake a claim, and some eighty thousand hopefuls, men and women, trekked west in 1849 to the Sacramento River where the original strike was made.

By 1853 the gold mining population had risen to almost a quarter of a million. Popularly known as the 'forty-niners', many of them never reached their goal.

Several pioneering groups took an ill-defined short cut and found themselves stranded in this awesome valley on Christmas Day 1849. Determined to find a way out, two of the menfolk – Manly and Rogers – set off and after an amazing two hundred and fifty mile hike into unknown territory over several mountain ranges and deserts, arrived at a ranch north of San Fernando. They returned with supplies and led the travellers to safety out of the place *they* named Death Valley. But at least all had survived the four-week ordeal; in summer they would surely have met a different fate.

Manly and Rogers' epic journey is enshrined in a trail, named for Manly, leading up the erosion slopes where one can get some magnificent views over the valley – but do that in winter, when the dawn is really worth rising early for.

Enhanced in the first light of a winter's day the sand dunes are incredibly beautiful. Driven by prevailing winds, the sickle-shaped barchan dunes wander across this corner of the valley, gradually uncovering the ancient glacial lake bed – its cracked mud surface pitted by pseudo fossil raindrop impacts looking like miniature lunar craters. (See page 109).

If you are wondering what this picture shows, it is just a rusty old tin can embedded in the mud. The picture's name is because I whimsically imagined a forty-niner dumping it on his (or her) way to fortune in the goldfields of California.

Death Valley dawn

Death Valley, California 1983; Agfa R 100 S. Plaubel Makina 67

Forty-niner
Death Valley 1983; Agfa R 100 S. Hasselblad 500 CM

As you view this picture, the raindrop impact dimples may seem to 'flip' into bumps. NASA astronauts noted this too as they studied photographs of craters in preparation for the first moon landings. Try turning this page through 90° or 180° to see if it happens for you.

Desert continuum

On a noonday mesa, airy ziggurat
tall with sedimented millennia,
I held a sandstone flag at my ear to
hear an ancient surf roaring white –
stranded now in Time's rigor mortis

on Moenkopi's rippled shores.
And beneath a fierce Mesozoic sky
I saw the glinting sands blush red,
drift off to bed with voluptuous dunes
blanketing the tree of life, till withered
it almost died.

In a waterless desert huge with silence
I stood on the edge of time
and watched a tired planet
turn to dust

George E. Todd 2002

Desert continuum
Arizona 1983; Kodak KR 64. Hasselblad 500 CM

CHAPTER FOUR
Derivations

In drafting this chapter I decided not to call it 'Abstract' because, in my opinion, this is one of the most *abused* words in today's visual arts scene. Regrettably, it is a term often used as a coverall for efforts that, if those weekend hobby painters were really honest with themselves, are not worth wallspace outside their fruitless *ateliers*. In my opinion they only serve to devalue art in the eyes of the general public.

On the other hand, real abstract art has been one of the most exciting developments in modern times. Several new ways of artistic expression were pioneered by some of Europe's greatest names in the history of twentieth century fine art. Many names spring to mind: Wassily Kandinsky, Piet Mondrian, Franz Marc, Paul Klee, Pablo Picasso and, more recently, Joan Miró. Their works now grace the walls of the world's finest museums.

Abstract art in all its forms spread to photography and early in the twentieth century Aleksander Rodchenko, Man Ray and Moholy-Nagy were leading the *avant garde* of photographic art in Europe – followed in the Forties by American writer and teacher Aaron Siskind. His motifs were everyday objects, forms and structures photographed as abstract equivalents of his inner feelings toward an environmental element or subject; inspirational images much admired by the Abstract Expressionists including Jackson Pollock, Wilhelm de Kooning, *et al,* exponents of creative painting on the wilder edges of modern art.

Significantly, however, Siskind's work was mostly scorned by the photographic establishment. While some of the pictures in these closing pages may appear similar to Aaron Siskind's, or the later work of William Eggleston, I was honestly not aware of this (or them actually!) at the time. My photo-abstractions are not intended to make any meaningful statement about art; they are simply images of everyday things that moved and excited me to see them differently, and to treat some of them to revision *post exposure* in the darkroom by traditional means.

As we move into this twenty-first century, the possibilities of doing such things electronically are enormous, and not wishing to be left behind, I am also learning to work with inscrutable computers and image processing programs, scanners and digital printers.

I still believe in the metallic-silver origins of photography, which should never be forgotten in the zealous haste to reject the old in favour of a new visual art form. Obviously there are some exciting trends in digital photography that will continue to expand – at best in a fruitful combination of both processes. It must not become trite and hideously overdone, however.

But for now, in a lighter vein, overleaf is a perfectly pointless picture (surprisingly, it was recently sold to a Swiss bank) from a series I started a while ago but abandoned when it seemed a pointless project!

To Dada

Tuscany 1995; Fuji RDP 2. Plaubel Makina 67

IMPRESSIONISTIC

Two Symi boats

Boats anywhere are a never-ending source of delight – whether one views them as artistic objects or enjoys simply messing about in them, like Toad. Given enough film, I could easily spend all day in a Greek island harbour seeking inspiration, returning again and again with new ideas.

Fe$_2$O$_3$ # 4

There was a rich store of images of my kind in Symi, and I recall many happy hours nosing around the steep streets leading to the old *Chora* above the harbour, but it was in the shipyard that I found an unusual piece of photo-art on the battered rudder of a small boat. Its odd mottled surface looked like an old Stone Age mammoth painting in a cave at Lascaux. It was probably nothing more significant than rust-remover that a fishermen had just applied when Mama called out to Konstantin that his lunch was ready…

The fishing boats were especially colourful, resplendent in an almost psychedelic range of colours: bright blue, orange and red, or all of these over different parts of a boat's structure. Their names were fascinating too: *Agios Vassilos*, *Agia Sophia* and *Agios Nikolaus* to list just a few popular Grecian boat names – and nestled among all the revered saints, a proud *Kapitan Stamatis* and *The Love Bot* (*sic*).

One freshly painted red boat without a name had that extra something for this photographer's eyes. A single white cloud in the otherwise clear blue sky was reflecting on the boat's sleek planking. On printing a small section of this image back to front – because it looked better that way – the cloud's birdlike shape led me to think of Marc Chagall and his doves or angels arcing over some abstract form.

Red boat
Symi, Greece 1985; Fuji RDP. Hasselblad 500 CM

To the Impressionists
Delos, Greece 1985; Fuji RDP. Hasselblad 500 CM

Delos

A field of wild flowers on the ancient sacred island of Delos – where one can see some of the most extensive ruins of classical Greece: the Sanctuary of Apollo, several temples and the Terrace of the Lions – gave me a Claude Monet lookalike landscape. Made as a hand-held snapshot while hurrying back to the boat, it is not as sharp as I would wish.

While I did use a tripod most of the time on Delos, back in '85, nowadays a camera set conspicuously on three legs at archaeological sites, or in public buildings almost anywhere in Europe, generally has the same result: you get chased off by security personnel. For them, there's no two ways about it: rules are rules. Whenever people see a photographer with a tripod, the universal assumption is that one is a professional on some kind of assignment. The irony is that most of my pro friends use 35 mm cameras, mostly digital now, shooting freehand.

Of course, one *can* use a tripod provided permission has been obtained beforehand from the relevant authorities – assuming you know where and how to apply. This usually takes several weeks and must be validated by a payment of some kind, official or otherwise.

The currently popular monopod had not arrived on the equipment scene when I made these pictures, though I had often thought about fitting a length of $1/4$ inch screw thread to the top of a ski-stick. I just wanted the fun of saying: 'But it only has one leg', on hearing the usual 'No tripods' cry! Patrolling site guards are probably up to such chicanery, now that monopods are so much in vogue.

Emaciated lion, Delos
(they're better fed in Trafalgar Square!)

116

To Monsieur Monet

The next full plate picture from the late Seventies is one of my earliest efforts made with a Hasselblad 500 EL/M borrowed to test drive a medium format camera. I fell in love with it, and could hardly wait to have one of my own, a 2000 FC. I've rarely looked back at 35mm since. Though there are hundreds of more recent images of a local lake, the Wesslingersee, in my files, made on various films and formats up to 4 x 5 inch, colour and black and white, I still like this impressionistic interpretation made on rather grainy Agfa 50 S film in 1978.

One of my first Cibachrome enlargements, exhibited in America in the early Eighties, it was made from a small postage stamp-sized extract of the original transparency. The abstract quality reminded me of Monet's famous water lilies in a series that he worked on for eighteen years in Giverny.

Generations of artists and writers have been attracted to the lake at Wessling, in particular associates of the Munich Landscape School of painters. Many well known nineteenth-century artists were among the frequent visitors to this exquisite little spot, most notably August Renoir. While in Wessling he painted two works now in a private collection.

Like many lakes in the area, it stems from a large piece of 'dead ice' left behind by the receding Würm glacier some eighteen thousand years ago. The landscape is dotted with kettle lakes and drumlins blending into gravel outwash plains, similar to terrain I've worked and travelled in – and photographed – on both coasts of Greenland.

Wessling lake is surprisingly deep with a large fish stock of various species, including the extraordinarily long-lived Waller that can grow to six feet long and weigh up to eighty pounds! This is not a Todd fantasy!

As soon as the lake freezes, and the ice safe to walk on, it is transformed into a classic L.S. Lowry or early Brueghel scene, full of people of all ages enjoying ice skating, hockey, curling or just pushing the baby in a pram across the lake, especially on a bright Sunday morning. Winter brings even more people to the lake than summer. Meanwhile, car parking becomes an even bigger problem every year, irrespective of the season.

Winter in Wessling

117

Homage to Monsieur Monet

Wessling, Bavaria 1978; Agfa 50 S. Hasselblad ELM

TRANSITIONS

Rust, glorious rust

Rust is one of my favourite motifs; there is always something fascinating to find on, or in, a corroded metal structure. Dictionaries define rust as 'a reddish- or yellowish-brown coating formed on iron or steel by oxidation, especially as a result of moisture' (*Concise Oxford*); in short: $Fe_2 O_3$. Either way, it has given me a colourful catalogue of rustscapes.

Sometimes these images appeared in the least expected of places, as on this typical getting-away-from-it-all outing to the island of Kos, just a couple of days before year's end. Like Symi, Kos lies between two pincer-like arms of the Turkish mainland. En route from Rhodes, the boat had called into the neighbouring island of Nyssiros where the crew had unloaded a few hundred boxes of whisky for the New Year parties – enough to pickle the whole population in alcohol.

After enjoying some pretty unruly seas on board one of Greece's worst, yet much-loved ferry boats, it was good to be on land again, for several reasons. It seemed, from the mood on board, that the crew were not too happy about their new skipper. They didn't seem at all helpful when he made a complete hash of backing into one of the harbours on route. Then, aside from the weather, the ship was renowned for its permanent list, rumoured to be a lopsided ton of concrete plugging a hole in its hull. It was particularly worrying to see so many passengers quite earnestly crossing themselves as they boarded this old tub! Boats of this vintage have probably gone to the breakers by now.

I remember being quite angry at the situation, another of Patricia's adventurous ideas, landing in the wee hours at such a godforsaken place. But it was much too cold to sit under the harbour wall, waiting for dawn and a *kafeneon* to open, so we headed into town to look for a room, followed by a pack of wild dogs snapping alarmingly around our legs.

After we had thumped noisily for a while on the door of a disco-bar, a youth appeared and, understanding the problem, guided us to a small commercial boarding house where it was his turn to bang on a door until the owner appeared – surprisingly, not too upset about being hauled out of bed at two in the morning. Apparently this was not unusual, as the ferry boats would often be late due to bad weather or some other factor. We heard later it was the only accommodation open, and were more than thankful to have found shelter and a bed to lie in.

As the warm winter sun eased away memories of a bone-chilling start, it soon became clear that my daily allowance of two films would not cope with the abundance of motifs. The quayside yielded many, like these lumps of iron scattered on the greasy wet stone. I nearly fell into the harbour in my enthusiasm to capture this image. Enhanced by splashes of colour where fishermen had beaten out their brushes right on the quay's edge, an unlikely motif to make an abstract for my next show.

Fe$_2$O$_3$ # 6

Kos, Greece 1987; Fuji RDP. Plaubel Makina 67

Rust is also just a passing phase during the transition from glory to complete disintegration – and a sad end for the iron horses one sees pensioned off to some forgotten railway or railroad marshalling yard. I still regard the golden days of steam with a large slice of nostalgia, and as a schoolboy probably spent too many hours watching those shiny green LNER Pacific Class locomotives speed past the end of our road...

Half a life later, and six thousand miles away, these feelings still move me – as when I saw the image $Fe_2 O_3$ #8 on a rusting railcar. It was languishing in the Aitchison, Topeka & Santa Fe (AT&SF) sidings at Magdalena, New Mexico, where the depot is now used as the town's council offices and public library. Many thousand heads of livestock were regularly shipped from Magdalena to Chicago and the slaughter houses of northern states. Countless tons of mineral ores from the nearby mining towns of Kelly and Riley were mule-packed to this vital railhead for smelters in distant industrial cities.

The history of the Old West was written in places like these, pioneer days when tough prospectors dug for wealth in the unforgiving hills. In the Great Depression, share-croppers and dispossessed farmers were forced to leave the Texas Panhandle and Oklahoma dust bowls, and head west for California – the Okies of John Steinbeck's epic *The Grapes of Wrath*. But by the time they reached New Mexico, the mines were already fading. Some settled plots of land were granted under the Homesteaders Act of 1862 in this old frontier region and many descendants of the original homesteaders are still out there, eking out a living.

The Kelly I saw was just a few foundation stones and roofless brick walls – and a tiny white painted church, its corrugated tin roof reflecting the bright New Mexico sun. The famous Tri-Bullion smelter was still standing guard along with the ghosts of courageous miners roaming the rugged Magdalenas.

Since my first visit, I am told the Kelly site has become a tourist attraction exploiting its geology and mining history, inviting visitors to pick over the colourful stones. There are said to be over 100 different minerals in the huge spoil heap – enough to keep an army of rock-hounds busy for many years to come.

Kelly mines

121

Fe$_2$O$_3$ # 8

Magdalena, New Mexico 1995; Fuji RDP 2. Plaubel Makina 67

Pie Town

Sitting almost astride the Continental Divide, Pie Town was originally shown on local maps as Norman after an entrepreneurial settler, Mr Norman, who opened a trading post in the early 1920's. It seems that old Norm baked fruit pies – so good that his shop became a favourite stopping place among journeying stockmen, who gave it the name Pie Town. Apparently some of those tough old cattle-driving cowboys had a sweet tooth, and wanted more than just plain doughnuts. When the Feds wanted to open a post office under a different town name, old Norm is said to have threatened the official: 'You'll call it Pie Town or get to hell out of here!'

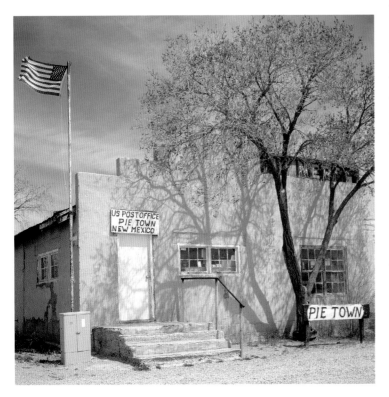

US post office, Pie Town 1996

The life and times of pre-war Pie Town were recorded by photographer Lee Russell, one of several people hired by Roy Stryker in the Farm Security Administration (FSA) project to document President Roosevelt's ambitious federal aid programme. Through the FSA, his aim had been to show the nation that his audacious New Deal was necessary and really working.

Stryker had had the foresight and good fortune to recruit some of the finest photographers of the period: Dorothea Lange, Marion Post-Wolcott and Walker Evans. While their portfolios may not have been exactly what the FSA was aiming for politically, they produced some of the most powerful black and white images of the times.

When I got there in '95, the old trading post had just closed down. Outside a defunct auto repair shop, a tattered Cola sign gave me another 'Remains' image for the collection, but apart from the post office there didn't seem to be much going on. Revisiting Pie Town a year later, I found the store had reopened under new management, and old Norm's apple pies were being baked again in preparation for the famous pie-eating contest that I especially wanted to photograph.

The event and a lively barbeque took place in a field that quickly became a slithering mire in a torrential rainstorm soon after the contest started. Local farmers welcomed the drenching – it had been another long dry summer, they said, but to pour like that, exactly on Pie Town's Festival Day, was real bad luck. The next day dawned under a deep blue cloudless sky; old Murphy's darned law had been confirmed again.

Remains # 13
Magdalena, New Mexico 1995; Fuji RDP 2. Plaubel Makina 67

A mote idea

Vaughn, New Mexico 1995; Fuji RDP 2. Plaubel Makina 67

Of pilchards and paint

Along the Portuguese Atlantic seaboard there are many picturesque ports and bustling boatyards; a constant source of images – oil-drenched machinery, rusty chains and peeling paint – however clichéd some may think them. Harbours like these are a boon for camera buffs, especially when the boats come in with their catch of fish – from swordfish to sardines.

Mention the word 'sardine' to the man in the street and at least one powerful mental image will immediately appear: Tokyo's subway riders squashed together – or a flat tin of small fish preserved in oil or a tomato sauce. Go to the fishing villages of Figueira da Foz, Nazaré or Sesimbra, and a quite different picture will emerge. First, there are over two hundred varieties of these members of the herring family, some much larger than the tasty little canned types. Secondly, in Portugal you will find that *sardinahs* are not eaten out of a tin, but grilled over charcoal or in a frying pan.

The European sardine is found not only off the Atlantic coasts of Spain, Portugal, France, and Britain, but also in the Mediterranean. Otto von Bismarck even linked his name to a soused variety of herring, still a great favourite in Germany. In some parts of Britain, sardines are known as pilchards.

Sardines are fished in most of the world's oceans, and besides being canned, smoked, salted or converted into other food products or oils, they are also used for a multitude of commercial or industrial purposes, even floor coverings and paint – all from a simple natural resource, and a tasty one at that.

Winter finds fishermen almost everywhere busy with repairs, scraping and repainting boats in colourful liveries, offering boundless artistic possibilities, especially in Portugal, Spain and Mediterranean seaports. The smell of paint practically overrides the all-pervading aroma of fish. Pictures like this pair can be found everywhere, though both of these resulted from a cropping session in the darkroom.

Using my favourite tools, two black L-shaped pieces of card, the prow of a boat was completely revisualized by rotating and inverting it to make *Half time blues*. The original transparency below shows how much I altered this image. Okay, I know this is the absolute antithesis of purist principles: that all images should be composed in the camera's viewfinder – but surely, doesn't this assume a perfect motif *exactly* fitting the viewfinder format? Of course, the picture opposite *could* have been made with a macro lens taking the same tiny abstraction – the only difference perhaps being the higher resolution.

Fishing boat, Sesimbra

Half time blues

Sesimbra, Portugal 1998; Fuji RDP 2. Plaubel Makina 67

Eyes right!

Sesimbra, Portugal 1989; Fuji RDP 2. Plaubel Makina 67

For W.E.
Kansas 1981; Kodak KR64. Hasselblad 2000 FC

6 x 41 + 80

Bavaria 1990; Fuji RDP. Ikeda 4 x 5 inch Wood View

With a circumference of about nineteen miles, the Walchensee is one of southern Bavaria's loveliest lakes popular all year long for a pleasant bicycle ride or lakeside stroll. I've made dozens of images there in 35 mm and medium formats but eventually wanted to do better with a view camera. My first Fuji 4 x 5 inch transparency was developed in C41 by the professional finishing lab who mistook the sheet film's identifying notches for an Agfa negative. I made a Cibachrome print with 80 extra units of magenta to enhance the bizarre colours even more than you see here and gave it to a surprised lab technician.

CHAPTER FIVE
The Photography

The earliest transparencies in this book date back to the Seventies and were exposed on Kodak KR64 or Agfa 50 S films. In the mid-Eighties I switched to Agfa's new R 100 S (later RS 100) film, before going over entirely to Fujichrome RDP. Except for the films exposed during my residence in America, the rest were developed in Europe, either by professional labs or myself using the handy 'cut and pour' Kodak E6 3-bath chemistry kits or the Tetenal equivalent in a Jobo ATL-2 Plus Autolab.

Except for a 35mm Canon F1, and a passing love affair with a vintage Rolleiflex 3.5F, the main workhorses were Hasselblad cameras backed up by a Pentax 67 with various lenses – and a Plaubel Makina (with fixed Nikkor 80 mm lens). For a still life or a close-up with the Hasselblad I used a Zeiss Planar 120 mm lens, while the 60 mm Distagon or standard 80 mm Planar lenses were ideal for landscapes and general subjects.

All my exhibition pictures are printed on Ilfochrome Classic (formerly Cibachrome), a material renowned for its incomparable brilliance, exceptional sharpness and enduring quality. While the pro Ilfochrome P3 finishing process is ideal for long print runs in the Jobo Autolab, I now use the easily mixed powder amateur P30 process for smaller quantities; it works just as well and, moreover, at a conveniently lower process temperature.

There seems to be no detectable difference in results from using either process. Normally supplied in bulk (25 or 50 litres) the P3 liquid version is intended for large volume professional lab processing, and is naturally more cost-effective.

In contrast to the chromogenic processes that use colour formers in the image development, (Ciba) Ilfochrome comprises three *pre-existing* layers of Azo dyes in the silver-halide composite. A conventional black and white developer is used to reduce the image, followed by a special bleach bath that removes all unexposed or unaltered dye layers before customary fixing.

Based on dye-destruct process proposed by Dr Karl Schinzel in 1905, Cibachrome emerged on the photo scene in the Sixties following research on colour materials by Ciba, the Swiss chemical industry giant. (Ciba took over Ilford in 1969 after the launch of Cibachrome; Ciba and Geigy merged in 1970.)

Several other companies, drawing on the pioneering research of Dr Bela Gaspar (the true father of this process), had tried to develop a commercially viable dye-destruct process – notably Agfa and the original Ilford Ltd, who both made their own silver-dye bleach materials used by professional photo finishers. It was the Ciba-Geigy-Ilford team, however, that finally made the sought-after breakthrough, followed soon after by Cibachrome A which featured an improved, shorter process.

It was an immediate success on the amateur market, which took to this new material enthusiastically, particularly in America. Since then, Cibachrome – now known as Ilfochrome – has undergone many improvements with a wider range of print materials, and has seen several new company owners! It is the simplest of all colour processes, and I am surely not alone in hoping that it will remain in production for many years to come. For positive-to-positive colour printing it is supreme.

After initial experiences with Beseler, Vivitar and Kaiser enlargers, I settled a few years ago on a 4 x 5 inch LPL 7451 unit. It has a 200 watt diffused light source which makes printing from high contrast colour transparencies relatively easy. In the constant diffuser versus condenser enlarger argument, opponents claim that diffused light cannot produce really sharp prints. Nonsense! Careless focusing is more often the real culprit. A grain focuser, even a simple model, is an essential darkroom tool.

For my first American exhibition, I tried mounting the Cibachrome prints in a Seal 210 press, as one does with fibre-based black and white papers. This resulted in an 'orange peel' effect on the print surface. An easier method (so I thought) was to attach a print, and the mat, to the backing board by a short strip of double-sided adhesive tape. I later learned that the tape and board were not of archival quality, and would have long-term harmful effects on the image. The inner layers of the mat board were clearly of wood pulp origin, as evidenced by the bevel edges becoming discoloured by out-gassing of the highly acidic lignin content.

Nowadays I mount Ilfochrome prints on acid-free board, using the postage stamp collector's method of attaching a print with a piece of acid-free tape. This is fixed to the board by a crosspiece of the same tape, thus allowing the print to adjust to any temperature or humidity cycling. Moreover, if the board (or mat) becomes soiled, or damaged in some way, it is then easy to remount the print on a clean piece of board. The overlying mats with a bevel-edged window machine-cut from acid-free board give the picture that all-important professional look. A strip of acid-free tape joins the mat along the length of the backing board, so that the assembled print opens like a book.

End words

Producing this book's 'dummy' led me into the world of digital imaging, at least in the scanning and layout work. Now I see just how much is possible that was simply not feasible by the old darkroom methods. Some of these images have been adjusted for the book in a way I had always wished, but was not able to do by conventional means.

This does not mean, however, that this might induce me to abandon silver-based photography; there are still quite a lot of advantages in real film over a 'virtual' image. I find it difficult to believe that digital images will accrue the same high values, in fifty or a hundred years, that the vintage prints currently enjoy in today's auction rooms and among their attendant collectors.

Preparing and copying the originals for the book emphasized my lack of perfect colour vision, a red-green deficiency – a male gene defect typically passed on from grandfather to grandson. Strange to say, as the work progressed, I noticed that it was possible to see the displayed or printed colours better, to judge their variations more accurately.

Juggling with colour nuances requires the same amount of patience as in darkroom work, though the material world of chemistry, paper types, filtering, masking, dodging and burning is far more substantial than electronic bits. One advantage of switching back and forth from black and white to colour, whether digital or analogue, is that one often brings new insights into methods and interpretation of both visual media. The cycle is thus continuous – and very contagious!

Good Luck!

SOME REWORKED IMAGES

While the majority of these images are only slightly cropped, usually to clean up the edges or exclude an image frame's rounded corners, some have undergone major reworking. An extreme case is seen in Chapter 1 'Pictorial' describing the making of *Awaiting Casanova.*

Other examples of manipulation include inversion and the creation of an entirely new image from a small part of the whole transparency. My original plan was to show lots of images in a series of 'before and after' comparisons, but after a dozen or so this would have become boring. Instead, I thought it better to highlight just a few of the more interesting examples of reworking as detailed below.

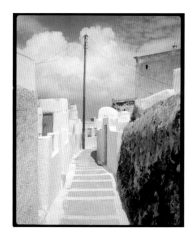

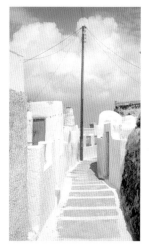

I've tested this theory in photo workshops. Using colour slides I asked students to say how they preferred a given picture. Based on simple observations like these, I found little evidence of a bias to the opposite of flow when people are left-handed...

To evaluate this left-hand versus right-hand effect with a new image, I hold the print in front of a mirror. It is astonishing sometimes just how different a picture looks when reversed.

Paros after HC-B

As the whole image shows, the house wall on the right-hand side is too dominant, diverting one's attention from the main object of the exercise – to show the beauty of a power line mast. By cropping away all of the brown wall, the picture takes on a new look that emphasizes the height of the power mast, making it a central feature.

Texas red grass

By reworking and reversing this image in the same way, namely simplification, the idea was to help one's eye follow the faint shadow to the top right-hand corner and out of the frame. This 'flow' effect, from left to right diagonally across an image (or painting), seems to be a normal phenomenon.

Nevada eventide

This resulted from a simple image cropping exercise to enhance the panoramic appearance of the final print – nothing more. But it lets me appreciate the revival of panoramic cameras at this time.

Chair lift

As I wrote in the text accompanying this picture, it was envisaged as a graphic design study before I even picked up the camera. It then only needed careful positioning and cropping on the enlarger easel to get the desired effect.

Red boat, Symi

This is probably the most extreme of all the revisualizations in the book. It was made at the peak of my enthusiasm for such photo-abstractions, something that is easy to do digitally now, allowing even greater possibilities.

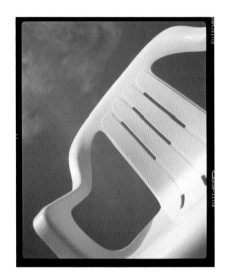

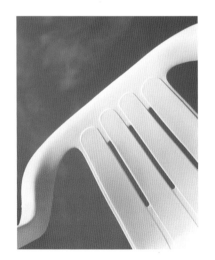

To M. Monet.

This picture evolved at the beginning of my abstract phase while looking for something new. It is a tiny extract of a previously ignored transparency that I held to be too grainy and too green. It helped me to an exciting series of images.

Fe₂ O₃ # 4 Symi

On studying this image below, on a light box, I was struck by its similarity to a prehistoric cave painting. Few people believe me when they hear that it was seen on the rusty rudder of a small boat in a Greek shipyard. Cro-Magnon man would not have believed it either...

To Dada

I couldn't resist this one in the winter quiet at Follonica, a resort on the coast in Tuscany opposite Elba. There was little to attract my eyes or lens except a few beach huts in need of repair before the summer onslaught.

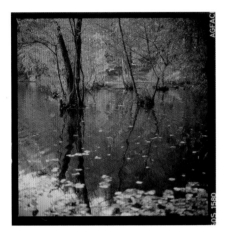

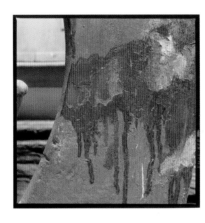

INDEX